Roy DeCarava
Photographs

Edited by James Alinder
Introduction by Sherry Turner DeCarava

Published by The Friends of Photography
Distributed by Matrix Publications, Inc.

Preface

James Alinder

All photographers who work as artists face the same dilemma—to reveal subjects in such a way that they become precise equivalents of the artist's understanding both of life and of the medium of photography. When the vision is lucid, as it is in these photographs by Roy DeCarava, there is no conflict between form and content. His pictures are no less art because their subject matter is our humanity; neither are they less human because of their elegant formal values. The intensity of feeling communicated in them is as basic as breathing; they are as complex as life's totality. Passionate and personal, yet public and aware, DeCarava extends and clarifies our world and our medium.

The term *artist* is abused to the point that anyone who buys raw sienna paint or 100% rag mount board is free to adopt the title. I wish it were reserved for people like Roy DeCarava who define so purely its classic meaning. He has spent his life in a creative pursuit, with little regard for economic hardships, simply because he needed to create. He had to make these pictures. In making them DeCarava has relied on his intimate knowledge of his culture, his creative instincts of visualization and his schooling as an artist.

From the streets to the hallways to the jazz clubs, DeCarava experienced that life fully and selected the perfect tool for transmitting his understanding. With his 35mm camera, Roy is unobtrusive, silent, quick. We feel a closeness that can only be accomplished through an intimate rapport with one's subject. Certainly a photographer concerned directly with our humanity must probe his consciousness; his philosophy of life must be suffused with the totality of the situation. DeCarava's almost daily contact with the camera has resulted in his producing thousands of negatives, a visual legacy we are only beginning to digest. To reduce Roy's staggering production to just the 82 photographs reproduced here was truly difficult. This is the first major monograph on the photography of Roy DeCarava. For an artist of his importance it should be the third or fourth.

Racial segregation has permeated our culture; thus it is no surprise that the photographic segments of the art establishment have been controlled by white males. Even though artists, and the art administrators who deal with them, tend to be liberal, they have not erased racial barriers. The same has been true of photographic historians, not to mention publishers. What is too often missing from our photography world is decision making that is sensitized to other value systems, that recognizes other visual priorities as legitimate, that allows the artists themselves to state what is important and then actually to listen to that voice.

The introduction to this book was written by Sherry Turner DeCarava from her unique perspective as both an art historian and an artist's wife. She has studied DeCarava's work for the past decade, has interviewed him at great length and has been an intimate to many of his photographs at the time of their making; she writes from an understanding of the artist and his work rarely realized in the history of art. Her penetrating observations allow a depth of understanding that previously has been rare.

It has been a continuing personal pleasure to have known Roy and Sherry for more than a decade. The DeCaravas have resisted the social deterioration that characterizes much of contemporary urban existence and have a lifestyle that does not rely on materialism as its basis. The strength, integrity, love and caring of their family is remarkable.

These are not pollyanna pictures. All is not right in the world as much as we might want to pretend that it is. DeCarava feels great pain and conflict, and makes unflinching photographs that examine those feelings. Yet his photographs do celebrate life, particularly on an individual, personal basis. They revere the family unit and question any incursion that would lessen those bonds. As an affirmation of life, the photographs of Roy DeCarava are a compelling addition to the history of art. They provide a vital link to understanding our nation's history.

Celebration

Sherry Turner DeCarava

Life sounds through the photographs of Roy DeCarava in singing tones. Beginning with the world, his pictures reshape and renew those things that we know but cannot bring ourselves to say. They are unflinching, yet feeling before the human condition as they carry us with them on a meditative journey through the imagery of relationships. The central spaces of DeCarava's photographs portray people and light, people and time, people and space, people and people. We can see these things, but other relationships are sensed in the photographs that are invisible, mysterious and deeply affecting. Something exists here between flesh and soul. There is no dispassion, no objective documentation. These are intense, perceptive images that recall the artist as one who renders a total state of consciousness, drawing on the social, the historical and the aesthetic, forming a visual repository for our lost memories. The things seen here we have all seen, all known; they emerge newly configured in a poetry of vision, newly revealed.

The pictures capture a moment of life that slowly unfolds its intimacy with the world—the strong, youthful beauty of a Mississippi freedom marcher, the nature of trees near numbered tombstones, the shimmering mirror beneath a mother's feet as she walks with her children in morning light. Rendered through a translucency of surface with detail recorded in the darkest areas, these pictures express a strength of imagery that reads beyond the sharpness of the focus. It is the concept of beauty within the photographs that embraces them and us. DeCarava expresses this quality through an ever-changing balance between rational order and intuitive process. Spatial clarity, formal coherence and structural definition are dynamically integrated with chiaroscuro, mystery and an imprecision of form. There is also a moral aesthetic in the work, a sense that truth is beauty. These concerns are central to the manner and place in which we meet the pictures. In the broadest of terms they express a fusion of classicism and spiritualism, a joining of the human-centered and the non-material aspects of life.

If we discard a useless soda can, Roy DeCarava finds echoes of beauty in its glistening surfaces. If we deem certain architecture devoid of human imprint and ugly, he sees it as a Greek chorus in a modern tragedy in *Four arrows and towel* (PLATE 71). If we throw away a human life by our uncaring and deem it untouchable, he presents Christ as a man in *Louise* (PLATE 69). There is a fundamental paradox in our lives that the artist understands and uses to express his values. Life and all the things that are necessary for its survival— among them love, companionship, feeling—are the expressions DeCarava acknowledges in his subjects. He often depicts couples, for example, because they embody the very dual nature of love and the intensification of positive life relationships. DeCarava understands that life is also fraught with other kinds of duality, however. There are relationships he sees and chooses to photograph that are not as positive, but are, nonetheless, very real. Some of these images, like that of the face in *Ex-fighter* (PLATE 42), are difficult to encounter. There are also other forces that go counter to positive life process, as in *Cab 173* (PLATE 46), where a man in broad daylight becomes a creature of the dark. Such forces in DeCarava's pictures are both visible and invisible; they may manifest themselves as a psychological valent of terror or fear, as a social valent of abandonment or as a human form. Yet there is no *nature morte* in the images. The pictures display an atomic life-energy as both positive and negative elements occur in relation to each other; an interpenetration and exchange of vital forces occurs on all levels. In the midst of these illusions, however, the photographs express not struggle but a sense of utter stillness.

Roy DeCarava began his career in art as a painter. A childhood devoted to chalk-art on the sidewalk and early art classes at Textile High School in New York City opened up the possibilities of pursuing what he decided at the age of 17 would be his life's goal—to be an artist. Early in his career he consciously set high standards for his work, even to the point of tediously mixing all his colors from dry pigment, oil and

varnish. This was more expensive than buying ready-made paint, but he insisted on doing such things even though he could not afford the time or money. He had a self-described sense of mission, a strong sense of purpose.

His formal training began in 1938 at The Cooper Union, where he completed two years of studies and learned the fundamentals of painting. After leaving Cooper Union he went directly to the Harlem Art Center, a WPA organization offering a range of art courses to Harlem-area residents. In 1944 he enrolled for a year in the George Washington Carver Art School in Harlem. It was here that he first met and studied with painter Charles White, whose attitude toward art was directly inspirational to him for its social responsiveness.

As a young painter working during the day as a commercial artist, DeCarava began to use a camera to make quick sketches for his paintings. He explored the medium gradually for several years before deciding, in 1947, to use photography rather than painting as his mode of artistic expression. "It was the directness of the medium that attracted me. Through the camera I was able to make contact with the world and express my feelings about it more directly." Continuing the imagery of his paintings in the new medium, he knew precisely what he wanted to do in photography.

There is no sense of groping toward expression in his early photographs, just as there was no searching for purpose in his life once he had decided to become an artist. The pictures from this period are masterful and classic in conception and execution; the limited technical training of his hand had been balanced by the tutoring of his eye. Through his courses, books and the work of other painters he learned about art. It seems almost to have burst upon his consciousness at the age of seventeen, at a time when he was intensely receptive. Every spare moment was devoted to his own photography. Later, during the 1950s, the demands of supporting a family, working and being active in the black art community left him little time to pursue other social contacts.

Edward Steichen, then Director of Photography at the Museum of Modern Art, became aware of DeCarava's work at this time through the efforts of Homer Page, the professional photographer who had helped DeCarava mount his first show at Mark Perper's 44th Street Gallery in 1951. Steichen encouraged him to apply for a Guggenheim Fellowship as a means of supporting himself while pursuing an intensive period of work and, in 1952, he became the ninth photographer ever to receive the award.

Some of the work produced during this period was published through the efforts of Langston Hughes, who co-authored with DeCarava in 1955 the slim volume *The Sweet Flypaper of Life*. The book received much critical acclaim, including awards for the best book of the year from both the *New York Times* and the *Herald Tribune*.

In 1958 DeCarava quit the commercial art field in order to freelance as a photographer. The jobs intially came sporadically, but in 1965 he was given a freelance contract with *Sports Illustrated* that cushioned his marginal livelihood. In 1975 he gave up his work with the magazine in order to teach photography at Hunter College in New York City, where he is currently a full professor.

To understand the sentience of DeCarava's photographs we must explore their shapes. Each picture seems as distinct as the human beings they often depict or the forms they decipher, yet they do form visual patterns. The subjects of many of these pictures compel their own order, for this work offers one of the most sensitive portrayals of black life and culture. Clearly, the specific subject matter does not represent the totality of DeCarava's vision, yet it is an essential aspect of his *oeuvre* and his experience is fundamental to the production of his art. He is a black man and his art equates his blackness with his humanity, yet as a man and an artist he is essentially singular.

DeCarava expresses his unique vision through structures of space that are the signature of his art. This characteristic of his work is clearly evident in his exploration and development of the ideas of the scale of walls and the impact of perspective as visual and social phenomena. The physical relationships presented undergo transformations of form, substance and meaning that assume, through time, the shape of an intricate improvisatory music.

A wall is a construction made by human hands, with bricks arranged until their horizontal layering produces an imposing verticality. A wall is direction also—up and down, side to side—its surfaces suggest patterns of seemingly infinite tonalities. It is difficult to separate the idea of a wall from its process of construction. It is a uniquely human achievement. Each brick carries the weight of time, effort and human energy; the wall expresses both the reality and the aesthetic of density, of intensity, of humanity.

There are walls that can only occur in cities, that vault endlessly upward and outward in all directions. They stand in DeCarava's work as a metaphor for our social existence in

this environment. Fundamental to this recurring metaphor is the concept of scale, of the relationship between human beings and walls. This kind of image provides complexities for those who can see them, an inherent richness of form and meaning.

It is hard to imagine a greater disparity than that presented in *Two boys, vacant lot* (PLATE 2). The children are very small compared to this geometric object that soars off not only in two directions but three as its horizontal expanse rides an oblique dimension. Evenly toned printing controls the power of this receding plane and holds its incidental brick patterns in restraint. The vacant, rubble-strewn lot extends the wall forward and serves as a visually disordered counterbalance to it, yet transforms it. The entire picture, including the wall, becomes a vacant lot. Our sense of desolation extends and deepens. Children play here; they have taken on the vocabulary of the environment and become geometric ciphers themselves.

There is sheer beauty in this desolation, however, in the tonalities, the flecked highlights of rubble and garbage swept ashore to the wall, in the wall itself breaking at the edge of the picture as geometric design gives way to an impressionist rendering of the sky. In the context of this beauty there is communication, for here on the wall floats a ''c'', the ever-present handiwork of man or child, underlined for emphasis and enigmatic in its suggestiveness. In spite of their size, the children dominate the landscape, and the wall, in its vertical ascension, echoes their vital presence. It is the gesture of play, reflected in the edge of light on an arm, that provokes the picture's deepest social meaning.

The relationship between people and walls is reformulated and given a different connotation in *Woman walking, above* (PLATE 5). Here the wall becomes a sidewalk and street, creating a sense of vertigo by extending horizontally its vertical dimension. The social meaning of this disparity in scale is muted by the visual expression of rhythm. The laws governing our perception of the ''wall'' in this image are manifest as a cadence of discrete parts; the oblique presentation creates as well as gives character to pictorial space. Of what importance is such space? Space is needed by human beings and is thus never abstract, never empty; it is space for breathing, for living, for walking. While the street divides space in this picture, it is the woman who generates tempo as her gait measures a distance that will repeat itself, suggesting a kinetic progression through the picture. Even though she walks away from us, we have a sense of her interior life and thus she comes close. The surrounding space mirrors her beauty. The street and sidewalk are a neutral expanse upon which her dark, erect figure is a strong accent. Subtle tones flicker like lights along her pathway. The sidewalk litter interrupts like accidentals across a sheet of music, while the tree branches hold notes the length of her hemline. An invisible arc hangs above and echoes her grace from another place. Rhythm and space merge into a lilting, gently swinging, uptempo vision, as an expression of her physical scale becomes musical scale.

With these shifting contexts for the disparity of size and space, other social meanings of scale evolve. *Man on elevated* (PLATE 16) asks in subtle, rich tones, in how small a space we can confine a man and his spirit, his humanity so large by implication. In *Child in window, clothesline* (PLATE 3) we see a small black child, jailed in the most immense of spaces, as ''Anna Heil'' recalls another Anne of history. It is daring to render such vast spatial contradictions, but the formal content is sobered by the print's social connotations. This is a real man, a real child; and neither are elevated into icons beyond our grasp of their personal humanity. Although we are separated from one by great distance and our perception of the other is diminished by the imperviousness of an elevated train's design, we feel these people intensely and personally. It is the beauty that impels us to come close in spite of the space; it is also some unspeakable element, perhaps fear, perhaps empathy. These walls are both jails and not jails, they play a deadly serious game with our psyche. We want to see but we don't. Will we?

In other photographs there are ultimate tableaux of people and walls, definitive in their social and aesthetic scale; ancient walls as in *117th Street* (PLATE 11) that open to us the ebb and flow of black life in the city and become the proscenium for the summation of life. There is in *Home for the aged, yard* (PLATE 60) a wall that looks backward to *Two boys, vacant lot*, taken fifteen years earlier. The more recent picture carries the richer spatial configuration that time might imply, but the symbolism of the vacant lot that was previously dominant finds only echoes here. This wall shelters birds and weeps at the human scene before it. Held in great tonal restraint, it is nonetheless a wall of intense emotion.

DeCarava's metaphoric *tour de force* is perhaps the visualization of wall scale in dematerialized *Sun and shade* (PLATE 14). Visual and social themes of black and white are

expressed through the three superimposed walls in the print— the sidewalk, the boundary between light and dark across which two children intensely interrelate, and the wall of fusion that encompasses the expanse of sun and shade. The sidewalk gives substance to both and defines with its texture their tonal and aesthetic values. Light is an activating principle in this image, a delineator of action. It has the capacity, like the artist himself, of transforming reality, of creating its own shapely silhouette of one of the children. Even in this most serious of situations—two children with toy guns are involved in an intense struggle that has nothing to do with play—darkness is not quite black, but has its own rich range of tonalities. It also has an emotional equivalent. In its obscurity and its lack of readability is a feeling of the mysterious. We can penetrate this darkness, however; there is an air in it, light and a child's life. These things of value symbolically draw us in; once we get inside we discover the photographer's vision of the dark.

This shadow has an infinite space within it. If the sun side is a sidewalk, the shade side is the firmament with billions of stars and galaxies, with mysterious black holes and clouds spreading endlessly. Light is a formal, descriptive quality, crisp and linear, that provides a clarity of definition. Darkness is an intuitive process that delineates mystery in spatial indistinction.

There is complexity inherent in these concepts of light and dark. We are presented with diametrically opposed values of sun and shade in this print that the artist renders as minimal tonal equivalents while preserving their peculiar aesthetic personalities. Other options were available. The shadow might have been printed totally black, or could have been opened up to render more clarity. In the face of these possibilities, the choice DeCarava made here can be appreciated as an early expression of an evolving aesthetic that depends on tension and balance.

> *I like the image very much because it is an excellent metaphor—light and shade, black and white, life and death. It took me a long time to print it properly—over ten years. I tried all sorts of things to make it work, to have this shadow dark and yet show the boy in the shadow; and to have the light part, the sunlit part, light with detail even though it was very bright. I didn't want to sacrifice one element for the other. I tried all sorts of things but nothing worked. One day I said, well, I'm just*

> *going to try to print it very soft and see what happens. And that's what really worked. I printed it on the softest paper I could find and pushed it as far as possible on the dark end and it came out perfectly.* *

It is the children who focus our interest in this print, who express the human scale of the walls and give them their real meaning. Ten years of tonal modulation of the image is expressed through the richness of thought that contradiction implies:

> *Who cares about two kids in sun and shade? I showed them in the symbolic visual context of the struggle of their life. They're in conflict with where they are, with each other, with two sides of a question; one black, one white. Many of my pictures represent deliberate, calculated choices. They may seem outlandish but it is because I try to force things to work based upon my determination that they are right, true. I don't look for pat things; I look for what I know, for what I feel is positive. Everything in my work is purposeful, even the accidents.*

The visualization of the scale of walls is the poetic matrix in which this human imagery is rooted and from which it grows. The wall is a screen upon which the personal, often solitary figure looms larger than would any physical reality. It is always self-referential, as an intensely visual expression of light and tone. Yet its ultimate function is to evoke and provoke, to extend the act of seeing into a wider comprehension.

> *I guess you might say that* Louise (PLATE 69) *is about art and nature. It's about architecture and empty benches and derelict chairs. And a man asleep in the face of art and nature. And it's about graffitti. And it's about the presence of unseen things and seen things in terms of the art work on the architecture. It's a strange combination of forms. The tree, if it did not have the trunk embedded in the reality of the grass and the side-*

*This and the following quoted passages are taken from an extended series of taped interviews with Roy DeCarava by the author.

walk, could be part of the image painted on the wall. The juxtaposition of a live human figure and the painted figure of dead Christ is no coincidence. The little black windows function as a counterpoint to other things, like the doorway where the bereaved figures cluster and the shape of that man lying down. It's like Two men leaning on posts (PLATE 58), *except that in this case one is an image and the other is real. Then the word love. . . .*

DeCarava's feeling for other qualities of space and scale finds expression in his treatment of perspective. It is not from any inconsequential motivation that we say "let's get a larger perspective" on an issue. Indeed, people wish to see more in the sense that seeing is knowing, knowing is understanding and understanding changes life. In Roy DeCarava's images perspective is often and simply a way of getting you down a street, yet it is rarely a place of departure connected to a destination. Rather, it begins nowhere in particular and ends nowhere at all, and in doing so it sets up a space for flow. It expands the two dimensional nature of the wall and, because it is spatially focused, suggests a different order of experience. DeCarava is not afraid to deal with these complexities; indeed, he seems eager to formulate convincing visual expressions for them. There is a largeness of vision in these pictures, a grasp of the intricacy and simplicity of life as they dynamically and ceaselessly interrelate.

It is of no small significance that images of New York City streets in 1952, such as *Stickball* (PLATE 13), present clear testimony that the city's streets were not only clean, with no gaping life-threatening pot holes, but they were also somewhat inviting. Yet the picture obliquely reminds us that no safer place exists for these children of the city. The cars sit while the people move and the children play in the foreground. Further in the distance people cluster to the sidewalk and cars resume their place in the street. For the moment of this picture, the children can play stickball. The square bases are drawn in chalk around the man holes, the game pauses momentarily to let a truck and car pass. A boy on the left, a strange expressive figure, walks alone, the entire stretch of block his own. Shade hides others as it extends from the building on the right. A child strides across the distant, sunlit intersection, dominating its space. These people are inconsequential, insignificant in the vast scale defined by the city's perspective. They are also so vital and expressive they can generate humaneness across even this great expanse. Their life-force dominates just as the child draws us to and makes meaning out of an intersection. As though to underscore the point the camera's exposure occurs at a moment when all trucks and cars appear not only stopped, but utterly motionless. Is it that the vehicles know, too, and express their deference? Or are they just being, for the moment, less threatening?

This clear, spacious and stately street, this place for flow is defined in great detail and breadth. The building facade is a dense buttress of harsh forms, flanking the receding and emerging line of perspective and providing rich visual contrast to it. These elements form an insistent cacophony, cushioned by the trees framing the picture's foreground and held at bay by sheets of sunlight. The fluid motion in these inhospitable public spaces reveals a personal time in which individuals closer than possible share their solitude with us.

DeCarava uses perspective in simple settings as well as in complex ones; in *Catsup bottles, table and coat* (PLATE 25), he presents the ordinary both as objects and as a moment of experience. A reviewer, writing of the beauty and perfection of this photograph, once exclaimed how artfully the scene had been arranged. But it was not arranged; like all of DeCarava's pictures it was photographed just as it was found.

The metaphoric levels in this image suggest a rich setting in the midst of these empty plates. The artist presents the paraphernalia and the time of taking dinner. Neither the items on the table nor, we imagine, the restaurant is fancy; the coat is timeworn. Yet light, shadow and darkness envelop these common objects and project the human life they represent with a quiet luminosity. Empty of material value yet full of spiritual value, the scene is an altar piece of beauty, humanity and loneliness. There are numbers here, two catsup bottles and one coat. People who live alone, who eat alone, know the meaning of such numbers.

There is a sense of quiet and ironic humor in viewing a table where the meal has already been completed and where we were not invited to eat. There is also a pun, serious but perhaps unintentional, on the bountiful table scenes of romantic still-life paintings, rendered here in its modern manifestation as an almost bare table stacked with used dishes. Yet none of these ideas approach the heart of the image. The picture really exists as an invitation; the receding lines of the table's edge quietly marshall us toward the back, where we are invited to enter into darkness.

The photographer expresses himself through this mystery and seeks to resolve our natural dislike of darkness, of the unknown, by allowing light to enter in. For DeCarava this space is not fearsome, it is a lively darkness, penetrated by an element of light and an implied sense of order and reason. It also connects us to vital life processes that depend upon intuitive, intense feeling. To experience darkness, we experience an intense awareness of self. Thus, *Catsup bottles* represents two portraits, although the subjects are only implied. The woman at the table and the viewer in the dark are close to one another. There is a circuit of shared intimacy in this picture that is carried by the darkness; perspective creates an entrance way through the corridors of which we imperceptibly slip into a space greater than the physical, a space of intimate confines.

> *My concern is always in how I use the light, process my highlights, modulate my grays. The emphasis is really not on the black tones. Most of my images that seem black are not black at all, they are a very dark gray. I only use black when there is a black object, when it's solid, when it's a black wall. But space is not black unless there is no light, and since there is always a little bit of light, such space is always dark gray.*

Light has its own particular qualities. Sometimes it can be a revelator, as in *Graduation* (PLATE 1). Other times it is purely mysterious, as in *Embroidered blouse* (PLATE 66). But in *Catsup bottles* it is a soft, tender reminder of the edge of things. It renders visible a woman in her coat. It is a cloth upon the table for our eyes to experience. The feast here is translucent light.

> *I often use a commonplace object as a symbol. I find it incongruous that a coathanger should play such an important part in an image, but it does* (Coathanger, PLATE 43). *It defines the quality of the image, the maximum light of the image, because everything is dark. In a way it defines the content and importance of the photograph because it's part of a human's belongings. It's a coathanger and what does it do? It hangs coats and coats hang on people. While there are other things in the image that suggest human activity, it is the coat hanger that has a personal, individual quality to it. It is true that it has probably seen many coats in its day, but it is still more unique, more personal than anything else because of the strength of its light and because of its position in the rectangle. This is a picture about nothing. An empty store, a restaurant—not even that. It's a lunch counter with tables! There is this elegant light on this plebian coathanger. It's just gorgeous. The blackness in this photograph has to be modulated and printed in such a way that it is not a flat wall but becomes space that you can go into and emerge out of; not a black mass but a black opening. The key lights hold the print in a physical way; they hold the black by defining the print so that you can go dark. If they weren't there, it would be a dark pit, a dark print. This same effect occurs in most of my work. In* Coltrane and Elvin (PLATE 40) *the highlights on the horn define the parameter of the print. As long as I maintain them it is possible to do almost anything in the image. They give the print a sense of reality and by defining the reality of it they keep it on anchor so it doesn't go away or sink.*

> *There are a lot of things in my pictures that have deep meaning, not just in the intent, but in their coming into being, their making. But before they can be made you have to understand what is being made. It's almost like you are redefining a situation, saying that this is more than what it is. It's not a lunch counter with a coathanger; it's more than that, and most of my images express this.*

Other interiors have perspective, also. We are very aware of the bilateral symmetry and multiple perspective of *Subway stairs, two men* (PLATE 29).

> *I was conscious of everything: the bannisters, the ceiling lines, these two figures on either side; and then, the man at the telephone, standing there like a period at the end of a sentence.*

We do not want to descend this staircase, but we must. We are taken down by the logic of our position, by the rationality of the perspective and the flow it implies. Logic itself is never enough, however; to it must be added entice-

ment. So the litter glimmers as we move down further, past these columnar figures who stand like Greek statuary, marking the entrance to their underworld. In these lower depths, two figures are intensely unaware of each other; a third half-figure stands before a tool of communication that gleams incongruously. The intersecting, multiple perspective lines emphasize the isolation of the figures, who, by coincidence, have come here on their way to somewhere else. Unconscious of each other, they are nonetheless profoundly related.

The central portion of this image contains only empty floor space. It has no content beyond the visual, but the purely visual often has meaning in DeCarava's work. This vacant floor is a place for the mind and eye to wander, to contemplate a quiet and extraordinary pathos in the midst of a commonplace scene in the New York subway system.

The tone and tempo of *Dancers* (PLATE 32) suggests a totally different sense of perspective. Rather than no action, there is dance action, jazz dance action. The digestion of life in this great funnel-like cavern is at moments gutsy, visceral.

This photograph was taken at a dance of a social club at the 110th St. Manor at Fifth Avenue. It is about the intermission where they had entertainment and the entertainment was two dancers who danced to jazz music. That's what this image is all about; it's about these two dancers who represent a terrible torment for me in that I feel a great ambiguity about the image because of them. It's because they are in some ways distorted characters. What they actually are is two black male dancers who dance in the manner of an older generation of black vaudeville performers. The problem comes because their figures remind me so much of the real life experience of blacks in their need to put themselves in an awkward position before the man, for the man; to demean themselves in order to survive, to get along. In a way, these figures seem to epitomize that reality. And yet there is something in the figures not about that; something in the figures that is very creative, that is very real and very black in the finest sense of the word. So there is this duality, this ambiguity in the photograph that I find very hard to live with. I always have to make a decision in a case like this—is it good or is it bad? I have to say that even though it jars some of my sensibilities

and it reminds me of things that I would rather not be reminded of, it is still a good picture. In fact, it is good just because of those things and in spite of those things. The picture works.

Yes, the figures bespeak a sophistication and a hipness. They have a quality of life that's free, that's abundant; that dares to mock itself and that dares to be "whatever they am and don't give a damn." There's that quality to it, a rebellion against what they should be and an acceptance of what they are and what they want to be. Whether HE *likes it or not, whether* HE *thinks its for him—when it's really not for him at all, it's for us. So there's that quality, too, which ameliorates the other aspect of it, which is really within me as much as it is within them, the dancers. There's a personal involvement with what's going on here in an entirely different way than there is in other pictures. Here there's a resistance on my part, but it's all to the good because it's all about feeling, what you know, what you want and don't want.*

The importance of the occasion expands even further this duality of the performers, for there are not only dancers present. There is also an audience that confers upon the dancers their right to be there; a waiter who walks in his own specialized dance and pursues a responsibility that he has; and the photographer who has done what he must. They validate each other; there is a consensus, a willingness, "let us all sit here together." A ritual is taking place, a communion, as they participate in the body of black culture and partake of the spirit of being African, of being black.

DeCarava sees people in other performances that protect and nourish. Only later do we understand the perplexing social issues these pictures raise. Ritualized behavior reflects the performance of tasks undertaken in the service of societal or group goals and it finds expression in images such as *7th Avenue Express* (PLATE 17), where the perspective vision spatially interprets the singular direction of this activity. The goal and circumstances of the picture are so ordinary that one might momentarily question their existence. This is the time of going to work and getting home; the ritual of sitting, holding one's own hands, wearing the felt fedora and the black wool coat. In this glimpse of white-collar life, however, the ritual is not unduly emphasized, but is a background

against which we sense the personal expression of each man. It serves as a framework through which DeCarava studies the individual human life and the quality of certain expressly human moments. There is a tender poignant feeling to these men; a sense of their solitude even in their solidarity. Then there is the common, ordinary inconsequence of the moment, of bothering your neighbor with a question or a remembrance, that humanizes the context. The formal arrangement heightens the sense of personal time in this subway train by exploring the rhythm and repetition of the men through space.

Many of DeCarava's pictures have this understated, quiet tonality; it is essential to the poetry of his landscapes. Often images of magnificent intensity and proportion result when a wall and perspective work together, creating a montage effect to structure an image, as in *Gittel* (PLATE 8). On the left side densely packed signs, textures and odds and ends of the real world project a coherent, if tension-filled, flat surface. On the other side illusions of light, reflections in a store window, have a dreamy, delicate effect and produce a sense of endless depth and time. These two aspects of the montage—one hard edged, insistent and communicative in its reality, the other impressionistic and ambiguous in meaning—are more tangibly concrete than the content of the image itself.

The meaning of *Gittel* is not one of ritual or of scale, although echoes of both are present. The woman—a motionless apparition—and the mirrored window reflections are its focal points. They create a dual time zone as the figure of the child obliquely suggests contradiction. Through them a tension and balance evolves that is evocative of many meanings. This is one of the earliest of DeCarava's images to present the subject as a mysterious metaphor, expressing a complex psychological reality in a moment of stillness. *Gittel* shares this aspect with other photographs as these spatial visualizations are increasingly layered and intensified to give expression to the artist's psychological penetration. Images such as *Hallway* (PLATE 26), for example, present a world of visual interactions between illusion and reality that also create a context for meaning.

If ever I wanted to be marooned with one photograph, I think I would want to be marooned with Hallway *simply because it was one of my first photographs to break through a kind of literalness. It didn't break through, actually, because the liter-*

alness is still there, but I found something else that is very strong and I linked it up with a certain psychological aspect of my own. It's something that I had experienced and is, in a way, personal, autobiographical. It's about a hallway that I know I must have experienced as a child. Not just one hallway; it was all the hallways that I grew up in. They were poor, poor tenements, badly lit, narrow and confining; hallways that had something to do with the economics of building for poor people. When I saw this particular hallway I went home on the subway and got my camera and my tripod, which I rarely use. The ambiance, the light in this hallway was so personal, so individual that any other kind of light would not have worked. It just brought back all those things that I had experienced as a child in these hallways. It was frightening, it was scary, it was spooky, as we would say when we were kids. And it was depressing. And yet, here I am an adult, years and years and ages and ages later, looking at the same hallway and finding it beautiful.

I can never understand that. I mean, here was something that was ugly and brutalizing and it turns into a beautiful photograph. Maybe it's because it is the past. It's behind me and I can see things in it that have nothing to do with my personal well-being. I can look at the textures of it and the light of it and the space of it and think of it in a larger sense. I still would not like to live in a hallway like that, but the important thing is what it evokes in me in terms of my past and my present. I can now see things of beauty within the body of its ugliness. For those reasons this photograph is a very powerful image. Both because of and in spite of its contradictions, its origins and what they mean, it is still a beautiful image. It's part of the seduction that's involved in art, I think, when you start with reality and make something else of it. The least you can do is to make something three dimensional into something two dimensional, but, hopefully, you go much beyond that. You can profit from a negative and make a positive. As beautiful as the photograph is, the subject is not beautiful in the sense of living in it. But its beauty is in

*being alive—strange that I should use that word
living! But it is alive.*

As light transforms this structure, a strange, life-like ambiance pervades the picture. *Hallway* projects a state of being that is not real in any objective sense; the walls seem to swoon and there is perhaps a feeling of malaise. It has a dream-like quality, provoking sensations that are at once physical and visceral, with a sense of floating, a loss of physicality. Opposed to this is the relentless progression of space into a somber, darkened portal towards a light that gives off no light. This is an image, like many others, that was not found but recalled. It recalls the human presence, the human scale as it exists on the bare edge of the real.

These intense psychological landscapes were explored throughout the 1950s. DeCarava's vision often returned to the outside, however, where his photographs defined other aspects of the environment. During this period he continued the search for a way to visualize the complexity of city life. He developed a mode of kaleidoscopic vision much more dynamic in its spatial configuration than his earlier studies and built upon oblique, intersecting lines and angular forms that charge intangibles such as air and atmosphere with meaning. It does more than formulate reality, however, often expressing a dramatic organization of space that can carry sharp and pointed undertones of danger, as in *Between cars* (PLATE 44) or as echoed in *Four arrows and towel,* while it conveys the aesthetic qualities that come from its faceting of light. Within the translucent pattern that results meaning flickers across the surface of these prints as wedges of light bring imagery in and out of focus. This kaleidoscopic vision does not essentially present a relationship of size in the environment, as do the images that reflect modes of wall and perspective scale, but like many aspects of DeCarava's vision it directly explores a psychological relationship. It often expresses the fragmentation of modern life, the disruption of the flow of time and space; yet these tangible physical aspects give way before the imprecise, interior interpretation of that experience.

Along with the complexity of content that emerges in DeCarava's photographs, is an exploration of metaphoric content, as in *Graduation.* Like so many of these pictures, it is a quiet image. A young lady is seen in a moment that represents a rite of passage, her high school graduation. She is prepared for the day. Her carefully adorned body expresses the fulfillment of her obligations, the tutoring of her mind. From this day she can enter society as an adult.

Juxtaposed to her figure is her environment. All around is desolation—a vacant lot, a street whose mysteries are garbage and decay and news of South Korea. She seems unaware, except for a slight turn of her head toward the lot, that she also participates in another rite of passage, one with symbolic overtones that are vast, provocative and personal. We don't believe she'll ever be touched by the encroaching shadows, though her forward movement is inevitable and inexorable. The lot threatens her, the slices of shadow cut across her path and dare her as images on the wall vainly chorus her tragedy. Still, we perceive her as not moving. She stands as a sentinel for all our hopes; for purity, for innocence, for positive life values. In this sense she is a classic figure, not only in the purely visual terms that define her drapery and her quintessentially feminine stance, but in philosophical terms as well. Yet we wonder what the future of this child will be.

In the midst of this complex, suggestive imagery a singular black hole sits absurdly in the center of the composition. The object itself, the artist tells us, is an overturned bus stop sign—a fallen soldier, a victim of urban chaos. It is also a void that emanates signals as a conscious, controlled form in a context of disorder. *Graduation* has changed from reality to metaphor to metaphysics.

During the late 1950s DeCarava first began to pursue photographically his intense interest in jazz music. Over the years this involvement led to hundreds of pictures of artistic and historical importance. He initally worked at festivals, late night clubs and jazz spots in New York, and later in other cities as well, photographing many of the important jazz artists of the time. A high point of his kaleidoscopic vision occurs in one of these pictures, *Haynes, Jones and Benjamin* (PLATE 31), an image of pulsating interplay between shape, light, plane and movement.

This picture captures the rhythm and grace, the openness and space of improvisatory music. Classical black American music, jazz exists as a moment to moment expressive interchange between musical voices, much like the individual pictorial voices of light, shape, shadow and plane in the print. Rhythm, close to its ancestral African drums, produces a multilayered polysyllabic aesthetic. The composition of *Haynes, Jones and Benjamin* has a vital, architectonic feel in the upbeat tempo, the heel lifted from the floor and the slight tilt to the stage. From floor to ceiling the formalities

swing. The intense density of *Graduation* becomes open, crystalline space modulated by a rich range of tonal values across which the viewer's eyes are free to wander and explore. The figures, with their succinct, dynamic shapes, staccato like quarter notes across the tonal reflections of space. This could only be a photographic image and it could only be about jazz.

It is also not about jazz. With a subtle but important shift of emphasis it is about workers, musicians as workers. Musicians carry music physically and mentally and the physical labor involved is a labor of love, with attitudes that necessarily reflect discipline—tautness and control. The two converging figures, Roy Haynes and Jimmy Jones, talk business; Joe Benjamin carries his tool in a struggling, yet ballet-like step of balance. Indeed, *Haynes, Jones and Benjamin* is about movement as dance, a theme whose development can be traced through *Graduation; Woman walking, above; Dancers, 117th Street, Stickball* and others. Human vitality is expressed through space, flow through time and confluence though improvisation. This picture moves with the daily rhythms of life until its patterns crystallize a timeless music.

There are muted elements of contrast in these images, between the figures and their surrounding space, that reiterate the importance of contradiction and opposition as pictorial elements in DeCarava's work. Other photographs, however, depend on the aesthetic impact of contradiction to such a degree that other visual aspects become secondary to it. This visual disparity is found in a richly diverse group of pictures, including *Window and stove* (PLATE 10), *Man leaning on post, truck* (PLATE 56) and *Subway ceiling* (PLATE 59). The earliest of these, *Window*, contrasts the tones and shapes of the cooking implements with the translucent montage of the window, rendering in rich tonal gradations the polarities of existence and feeling in seen forms that reach their synthesis in an unseen person. *Out of order* (PLATE 28) presents an organization of the wildly disparate, with pictorial and literary iconography explicitly stating contradictions and implicitly expressing a society's attitudes toward its female population.

Two women, manikin's hand, (PLATE 9), on the other hand, implies psychological disparity without stating it. In this picture DeCarava establishes a vehicle for the projection of his own psyche as it mingles with reality; and in the process he defines a surreal landscape. Two passersby stand before a display window, each one isolated and different. In the center the white hand of a manikin seems to reach out toward them, threatening ominously from the draped shadows of this barricaded window. The artist has called it "the ghost hand", and as an archetypal element it appears under different guises in a number of other pictures, such as *Broken railing* (PLATE 20), *Force* (PLATE 52) and *Boy in print shirt* (PLATE 78). There is an hypnotic silence created in *Two women* as our attention swings between the women and the hand. An absurd padlock sits in the sun and marks time. The woman on the left is defined by her scarf, beautiful in the congruence of its texture and tone, volume and design. Her face reflects a condensation and concentration of form suggesting an interior state of being. The hard, linear, savvy face of the other woman balances the bare edge of beauty's visage. Their identities slip imperceptibly back and forth from anonymous pedestrians to priestesses of beauty and wisdom.

Many other things contribute to the singular impact of this photograph. Made in 1950, it is one of DeCarava's first close, personal views of people on the street. Getting close and having that physical proximity express more than just distance cannot be taken for granted in photography, either in its mechanics or in the photographer's development of a requisite attitude. One first has to want to be close, then devise ways of doing so unobtrusively; it is a question of both space and psychology. *Two women* achieves this kind of purely psychological impact, projecting it onto an aesthetic base, it is rooted in but removed from its immediate subject. An intensely communicative image, we search for some explanation that will bring us from its precipice of fear to a more rational world. It is breathtaking. In one moment it all could have changed, for these women merely stopped to admire clothes in a store window. In this moment, nothing "happens", yet everything is happening.

Danger is the subject of this picture, danger in the streets, in our lives; imaginary or real dangers that spill out from places as we pass. There is also an element of ambiguity. Is the ghost-hand seeking to cauterize a victim or is it trying vainly to touch, to feel? That the image portrays a dichotomy between black and white people reflects only an objective reality. The visual statement here is hardly polemical; indeed, it is richly ambiguous.

What is difficult in this picture is not objective reality but psychic reality, for the violence is not finite. It *only* threatens. The perverse truth is that were the act directly violent we might more readily accept it. Such acts accomplish an end

and there is no enduring reminder of the event as bodies disappear. The act depicted here, however, has no end; its terror is infinite, always hovering, waiting. There is an insanity here, a reality that Kafka knew, that many others understand. Light strokes an eyelid; harsh, glinty light makes metallic curls shine; *Two women* expresses a dialectic of the sensuous and the surreal.

One always returns to the closeness of these photographs, to how deeply they sense and portray the interior nature of experience. Perhaps this is why the personal study is central to DeCarava's work. These pictures express the artist's perceptions of interior human life in the context of its greatest meaning. There is no intervening device here, no single visual conception that arranges the picture's complexity, because it has all been reduced to a minimum. Although the physical distance varies, the closeness is reflected in purely poetic visual renderings that explore depths of human understanding.

There are discoveries in these images. The photographic presence of the subjects and the heightened sense of their physical surface seems to diffuse outward, carrying an intangible, eternal presence. They are recalled images that, like *Hallway,* impose an almost dreamlike state. The images seem to wait as we slip into their presence, outside of time. We discover the eyes of a haunted house in *Ex-fighter* and ethereal unions in *Milt Jackson* (PLATE 34), yet we sense parallel movement in their different beginnings and ends.

There is a dance ritual in Haynes, Jones and Benjamin. *It is a dance of being, a dance of leaving, a dance of beginning and of playing. It is a movement that is not about walking but about movement.* Milt Jackson *moves from that ritual to religion, because if ever there was a moment of religiosity, this is the moment that I felt. There was an out-of-this-world concentration of the musician and there was a sense of reverence in his posture, in his attention and his concentration, just in the way he held himself—the thrust of his neck, the hands almost clasped in prayer. That's why I like this image; there's nobility about his standing. In a way, it reminds me of* Woman in sandals (PLATE 50), *and* Tombstones and trees (PLATE 70). *There's that straightness about it, that uprightness, that rooted quality; it has a regal quality.*

There is something joyous about people being totally committed to what they're doing. This is part of the excitement in seeing musicians work. You can almost see them play; not hear them, but see them play. They are so totally committed, so involved and so with the music that even if you don't understand the particular music, it is still a joy to behold.

This is what I found so attractive about musicians and it applies to anything that people do. It is a healthy, a human and a very beautiful capacity. I think everything in the picture works toward that. The out of focus figures, even my little dots come across; everything down to his beautiful striped suit, which is ever so subtle and ever so beautiful. This image speaks of a true religion, if you will. It is the religion of commitment, the religion of work and the religion of selflessness; of giving oneself to what one does completely.

This photograph of a recognizable star portrays him in a moment of anonymity. There are portraits of other anonymous people here that do not portray them in a conventional sense. A portrait of a man need not be of his face; in the worker's hands of *Man with two shovels* (PLATE 35) we find an image that recalls Van Gogh's *Potato-eaters.* Similarly, the car in *White car and dots* (PLATE 45) is the object of a close, personal encounter and expresses many mysteries. In *Cab 173* a hand has its own being while its owner is a creature of the dark in the dominion of a numbered cab. Shadow and architecture in *Apartment for rent* (PLATE 73) assume a human aura as they talk to each other. The central figure in *Man with clasped hands* (PLATE 7) is flanked in his portrait by anonymous pedestrians who pursue their unrelated lives, yet the younger man is necessary to the older and something in the young woman is attendant like an angel. In *David* (PLATE 19) a small child stands in the streets of a slum with the name of a biblical warrior and a face of African aesthetic perfection, veiled in the expression of another time. A trilogy of photographs—*Night feeding, Sherry and Susan* and *Sherry knitting* (PLATES 64, 65 and 74)—discovers the responsibility of life.

These studies are wide-ranging in their content and vision, yet they share a mastery of visual essences that often allow sensuous physical substance to exist simultaneously with spiritual auras. In *Elvin Jones* (PLATE 41), an image of

the jazz drummer, these formal qualities achieve very subtle expression. There is almost no light illuminating the subject, yet we have a picture that explains a man. The things of his mind, what he has thought and where he has been, are visible on his face. There is an ambiguity in his face, an intense inwardness, a feeling of pain, anger, even meanness; yet it is not offensive, but beautiful. Jazz musicians express great intensity and their perspiration is an indication of that intensity. You sweat when you work hard, and as the sweat delineates the movement of Jones' face, it glistens like thorns. Flesh is dematerialized before our eyes by more than light, by more than what we can just see. The moment becomes the beatitude of a man.

Photographs where a fully developed montage structures the image and becomes almost as important as the subject appear at first to contradict the direct visual expression of these personal studies. Instead of presenting singular subjects, the reflected light in pictures such as *Hotel* (PLATE 47) and *Couples* (PLATE 38) creates layers of rich tonal surfaces, illustory depths and multiple images. In pictures like *Pepsi* (PLATE 62), a densely-packed, tension-filled surface is created by the close juxtaposition of forms and textures. The meaning of montages such as *Hotel* comes from their expression of implied mystery.

> *I don't know what I'm photographing except that I know I'm photographing a duplicity of the image, one which is real and one which is the reflection.*

Each mystery evokes a meaning which in its turn evokes the unknown; in *Couples* images float through the amorphous, dream-like space while a walking couple ambiguously interprets the expression of another relationship. The finite forms and the infinite nature of feelings, the definitions of line and the rich gradations of tones, the terminal of surface and the endless reflected space all intermingle in an expression of life through love.

DeCarava's involvement with multiple levels of content led in the 1960s to his development of a bivalent mode that fused the vision of his perspective studies with his close personal studies, creating a succinct poetic form. These pictures instruct us to see in two ways, to see in and out of focus simultaneously. This vision enables us to bridge spatial and temporal zones that separate figures; it requires that we make

connections to unify and synthesize distinct imagery, bringing everything close. The closeness depends sometimes on our grasp of religious themes within a context of other visual meanings, as in *Subway Station, Canal Street* (PLATE 77), where the human relationships depicted are psychological projections of the artist. In other prints, such as *Coltrane and Elvin,* we explore a relationship already in existence that is, nevertheless, open to a wide range of interpretation.

In this bivalent vision, the recognizable presence of one of the figures is reduced by blurred focus. This figure assumes the nature of a sign as its tangible physical body diffuses into a mysterious aura of being. In its very ambiguity the unfocused figure serves as visible evidence suggesting the existence of something implied in the photograph but not seen—the intimate nature of a human relationship. Through the bivalent mode the photograph itself becomes an enduring sign of human relatedness.

This aspect of diminished physicality reaches its zenith in the cut-form mode, in images radically cropped to emphasize the bold quality of design and the rhythmic harmony of form. The resulting pictures—*Force, Woman in sandals* (PLATE 50), *Bill and son* (PLATE 48) and *This site* (PLATE 51) for example—achieve a strength of beauty and meaning that carry within their signs an emblematic quality. This extreme cropping also removes the subject from its original context and often makes recognition difficult. It disrupts our normal visual vocabulary and compels us to see things in unconventional ways. Images such as *Force* are dazzling in design, puzzling and provoking in form and content.

> *I wanted to express something that always seems to happen to people, black people in this particular case. They are removing this woman from a demonstration and it is a display of force. Force is short for force and violence. I wanted people to look at this picture as an abstraction, then to discover what it was. This image is just a very small part of a negative. No matter how abstract it is, it's still what it is and you really can't escape it. It could have been made very dramatic, very forceful with all the gory details, but I don't think that's necessary. There are areas in which force manifests itself in pervasive ways and in quiet ways. Force, violence isn't always spectacular and*

monumental and epic. Sometimes it is very quiet and insidious, almost imperceptible. In a way, that's the approach I took in this photograph. It's the force of running water wearing down the rock as opposed to a volcanic force.

I think the action of water wearing the rock is stronger and more pervasive than the volcano. The trouble when this kind of force is applied to people is that the people don't know that the water is running, that the force is being used against them. They just know that things aren't right, but they don't know why. If it was volcanic, they could understand what it was and could defend themselves because they would know what to expect, where it was coming from. The kind of force I have depicted, on the other hand, is very subtle but it works both ways. The same kind can be applied by either side; the force of the resistance. There is also another aspect to it—force as the desire and the will by the majority of people in the world to reach sunlight. A drive for life, for fulfillment, is also force. It is stronger than those being used against these people, except that the forces being used against them are concerted and conscious whereas the will to life is still in its unconscious, intuitive stages.

In DeCarava's early work an intense quality of life is often conveyed in the movement of singular figures through the environment. During the 1950s this rhythmic motion captured the essence of human vitality in a girl walking, in musicians struggling, in pedestrians in dance-like motion. Such rhythmic movement imparts a sense of flow to the image, yet it also works against flow, stopping it periodically or impeding its progress as it focuses attention on the pulsating figures who assume the greatest importance in these pictures. Rhythm and flow emerged as distinct ways of structuring space during the development of DeCarava's work. Though they are in some pictorial conflict, they share in presenting the photographic moment as an expression of time. In the rhythmic mode, the moment is a singular, ultimate moment; with flow it is many moments in transition to others. In the 1960s rhythmic vision emerged as a major means of DeCarava's pictorial construction. *Three men with hand trucks* (PLATE 57) presents the rhythmic movements,

emphasized by a tonally flat background, of specialized steps developed by garment workers to pull their loads. Such work breaks men's faces, bends and twists human bodies; the dimensions of the photograph rest in balance between this reality and its tonal dance.

Bent heads also generate rhythmic impulses in *Four men* (PLATE 61), as a group of strong, steady, centered individuals contemplates something known and something seen. Rich, sumptuous skin tonalities resonate with these impulses; the inner direction of the men emerges outward as the crown of a head is bowed. Eleven years later, in *Asphalt workers* (PLATE 72), heads again emit rhythmic signals in a picture about many kinds of work. The heroic central figure carries the composition in the lift of his shovel. Surging downward and upward simultaneously across an amazing range of tonal patterns, the rhythmic power of his stance contributes to the impact of this statement about the labor of black men. It becomes a pivotal image through which the photograph achieves a state of suspended motion and time.

My pictures are immediate and yet at the same time, they're forever. They present a moment so profoundly a moment that it becomes an eternity. It's almost like physics; there's an arc of being. There's a beginning, then the peak is reached and then there's the end. It's like the pole vaulter who begins his run, shoots up, then comes down. At the peak there is no movement. He's neither going up nor going down. It is that *moment I wait for, when he comes into an equilibrium with all the other life forces—gravity, wind, motion, obstacles. Pushing up, he's stronger; coming down, he's weaker. The moment when all the forces fuse, when all is in equilibrium, that's the eternal . . . that's jazz . . . and that's life. That's when I believe life reaches its zenith, when the artist can anticipate that, can feel that, can absorb and use it. This applies not only to motion but to all things before the camera. For example, an expression can be in transit and there are points when that expression is meaningless because it's so transitory. But, there are moments when that expression reaches a zenith, when it is so real it becomes universal, it finds its stillness. If you don't capture it at that moment, all you get is a transitory particular. When you find it at the right*

moment, it is not only particular, it is universal. The only way to do this is to be in tune, to have the same sense of time that the subject has. This means you have to give yourself to the subject, accept their sense of time.

In recent years the concepts of rhythm and flow have changed in DeCarava's photographs. Rhythm has become muted and flow has moved from being a pictorial element to being in some sense the subject itself. Along with this change came a redefinition and a reappraisal of its character. Flow became anything of this world that moves—people, objects, even the intangibles of the real world like light and atmosphere—anything with the energy to issue forth in all directions at once. Flow is expressed by the space that moves around people in transit in *Fourth of July, Prospect Park* (PLATE 82). It is the people who flow up and down, back and forth with light and shadow in *Public School entrance* (PLATE 80). It is both the material and the immaterial that flow on a street in *Regal* (PLATE 81). In these pictures the confining boundaries of perspective are circumvented or deleted as a pictorial element. Life is expressed in a manner consonant with space and time.

In this newest work DeCarava has reshaped one of the basic formal principles that organizes his vision and the world he photographs. Although still classically composed, many of these images have a less structured feeling to them. People no longer struggle against space but are held in it, embracing the dual processes of vitality that carry all moments. This concept is not unknown in black culture; Langston Hughes suggested something of it in his poem, *The Negro Speaks of Rivers*. It is a rich and complex philosophy of life. It implies self-confidence in the openness and willingness to accept life in all its manifold forms and occurrences. It carries pictorial and philosophical complexity in the flow. There is a loss of individuality implied, a muting of individuality for the consonance of all things. We wonder, however, on seeing *Fourth of July* what will become of the little boy, the one who holds the transparent plastic tube. Telescoping this question back through the many images in this book, we find it implied, in one form or another, in almost every picture. More than any other idea, a concern and respect for the individual human life is central to this work.

DeCarava expresses the relationship of people to a totality of experience through his moment of ordering environmental space. Utilizing known and invented designs to order his changing and variable world, he creates a space that radiates meaning through its structure. His images are both immediate and forever, a tangible reality and the sign of that reality. Lacking the palette he had used as a young painter, he found through such visualizations as montage and wall, a canvas upon which to render infinite gradations of light that in their richness achieve a comparable expression.

When Roy DeCarava photographs people, he encodes his knowledge, his love, his understanding. In the face of stereotypic images about black people, he has sought to depict them as they really are. He understands their capacity for love, for compassion, for strength and for the positive values of life because his values have been nurtured in their bosom. These photographs penetrate the values and ethos of our culture and its people. The meaning of the work does not fundamentally rest in its portrayal of poor people, or of white people or black people. Rather, DeCarava offers thought-provoking images that radiate the nature and quality of human life as a deeply personal visual experience.

DeCarava's images are intended to bring us close. Through sensuous texture and tone, with a sense of stillness, quietness and waiting, they focus upon one loved, upon the possibility of love, even when it is not returned or is not yet acknowledged by another. The visual expression begins with a love of light and structure and depends upon a flowing conduit between this intimacy, light and structure. These are mediators, transporters of comprehension, as they carry his brief moment in an eternal vision. Each of Roy DeCarava's photographs—sensual and loving yet profoundly social and visual—reveals inherent beauty and celebrates life.

Sherry Turner DeCarava holds a Master of Arts Degree in art history at New York's Columbia University, where she majored in primitive, pre-Columbian and Afro-American art. She is currently a candidate for a doctoral degree there. She has lectured as a part of a number of symposia on African art. This essay is the result of a decade of reflection on and intimate contact with DeCarava's photographs.

PLATE I Graduation, New York, 1949

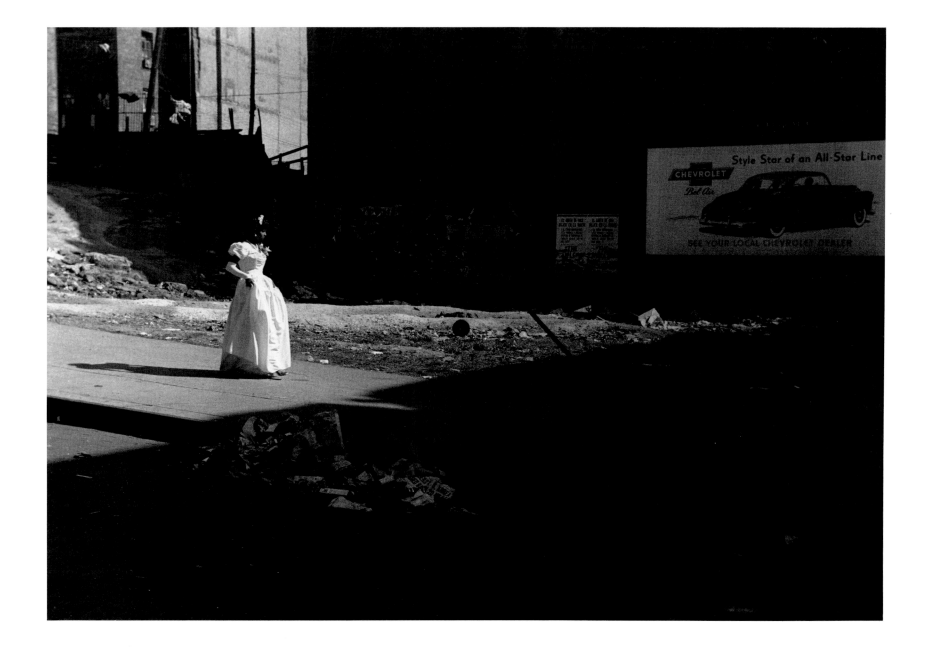

PLATE 2 Two boys in vacant lot, New York, 1949

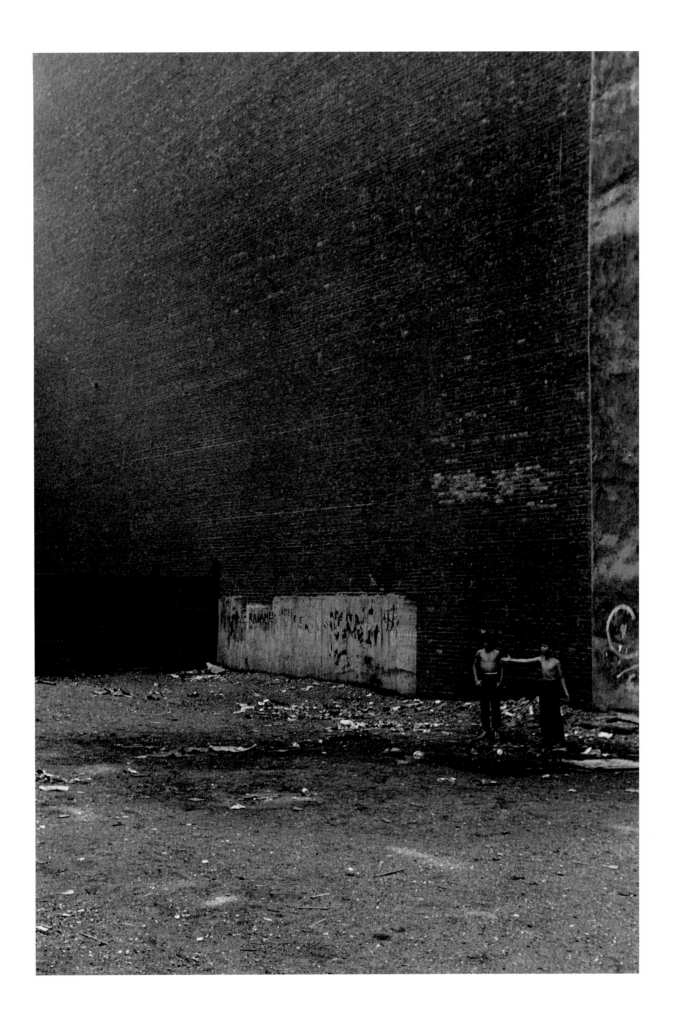

PLATE 3 Child in window, clothesline, New York, 1950

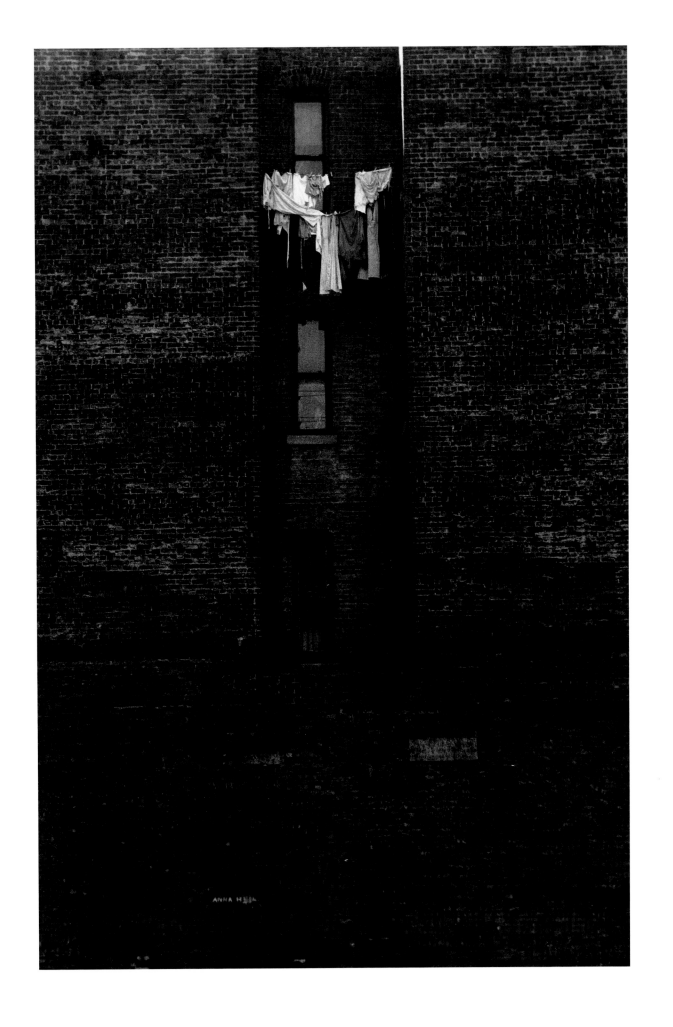

PLATE 4 Lingerie, New York, 1950

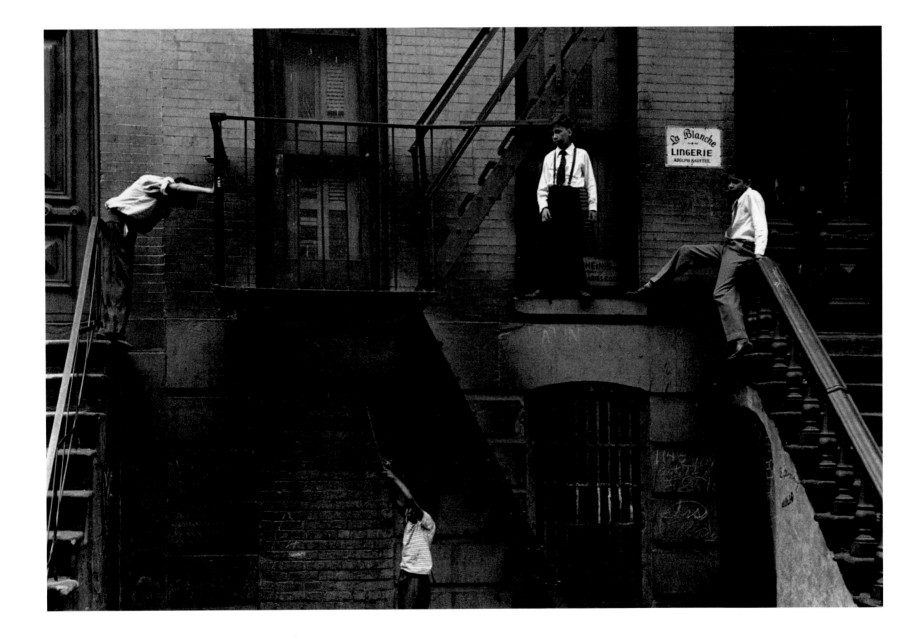

PLATE 5 Woman walking, above, New York, 1950

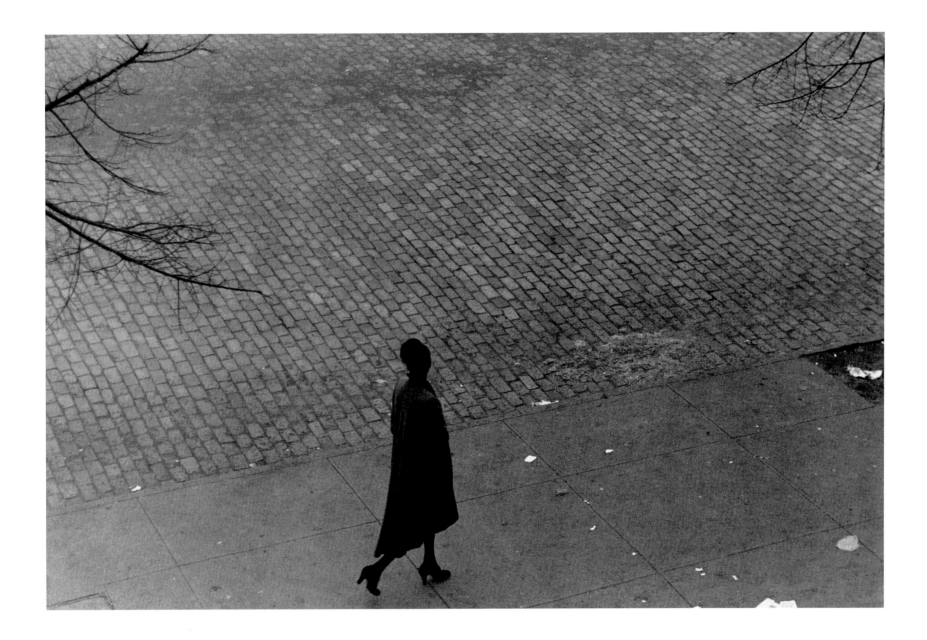

PLATE 6 Boy looking in doorway, New York, 1950

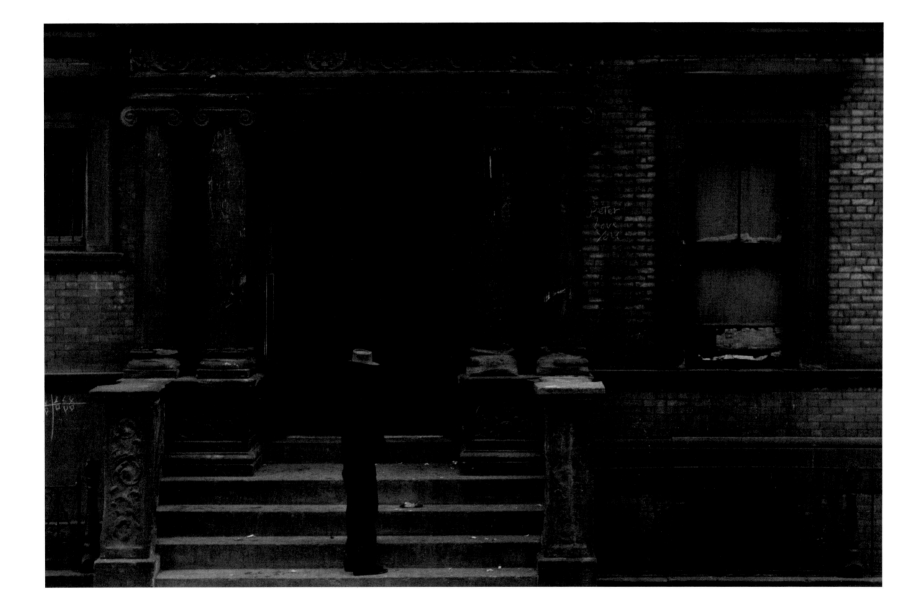

PLATE 7 Man with clasped hands, New York, 1950

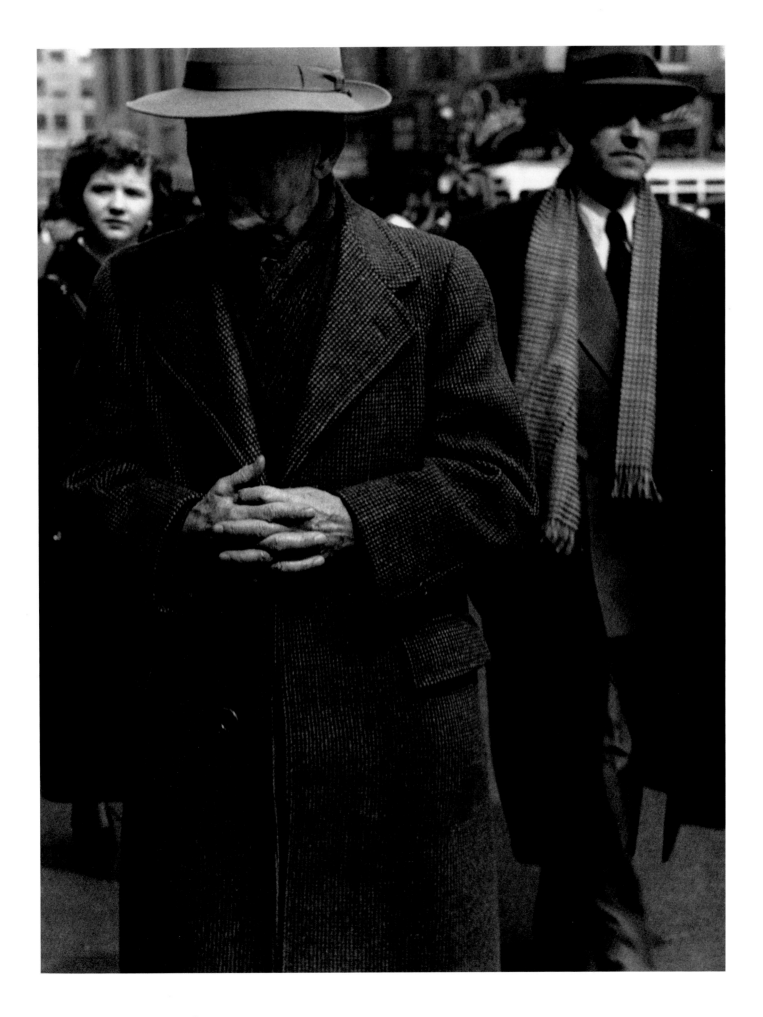

PLATE 8 Gittel, New York, 1950

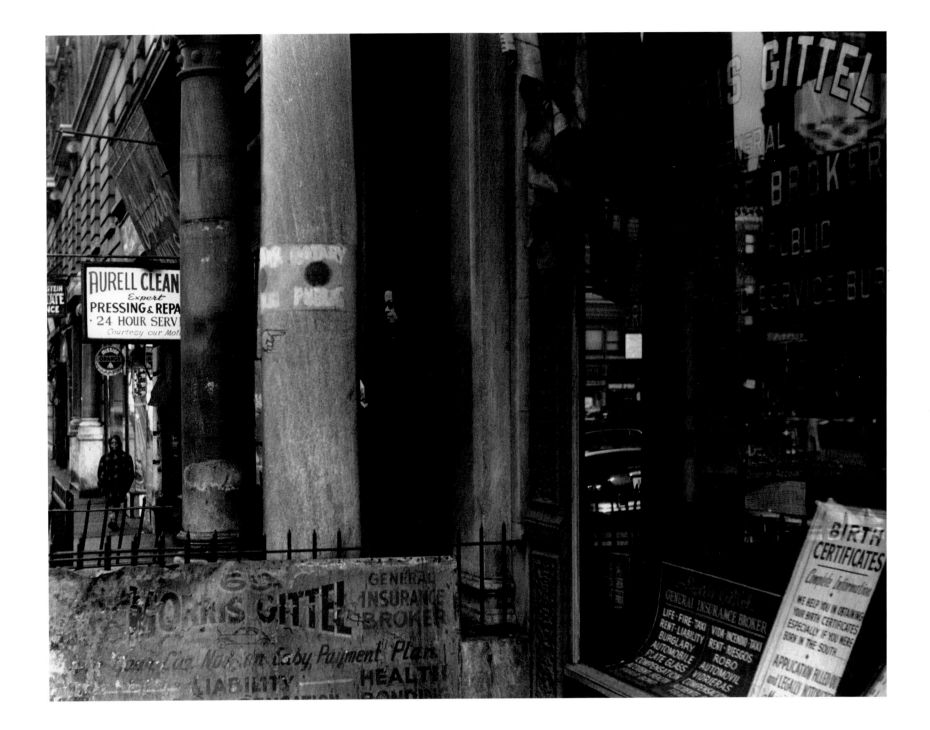

PLATE 9 Two women, manikin's hand, New York, 1950

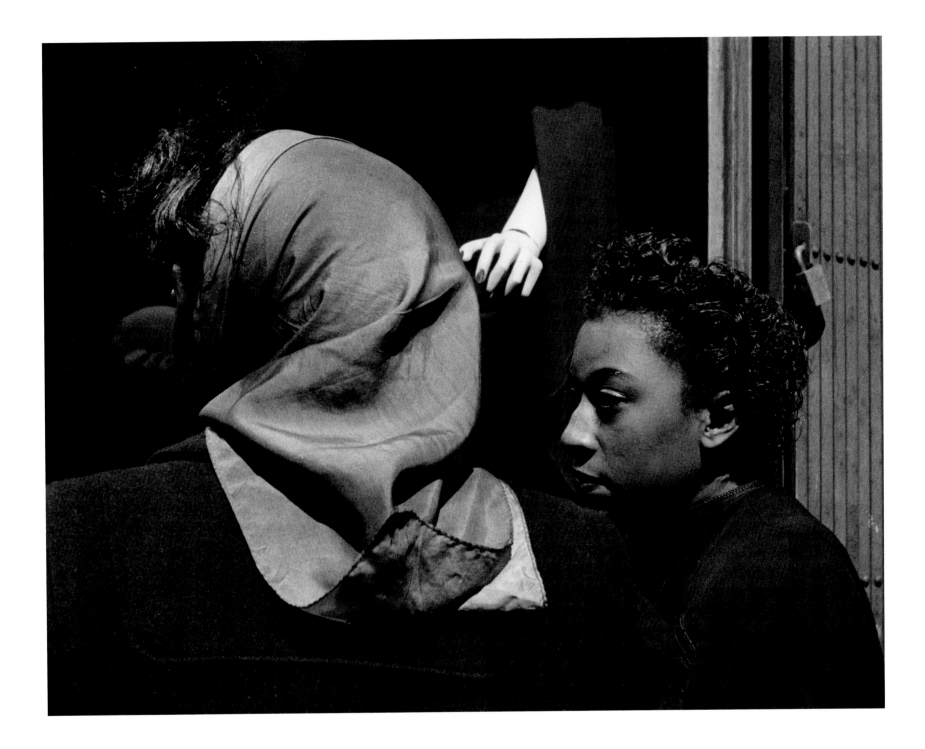

PLATE 10 Window and stove, New York, 1951

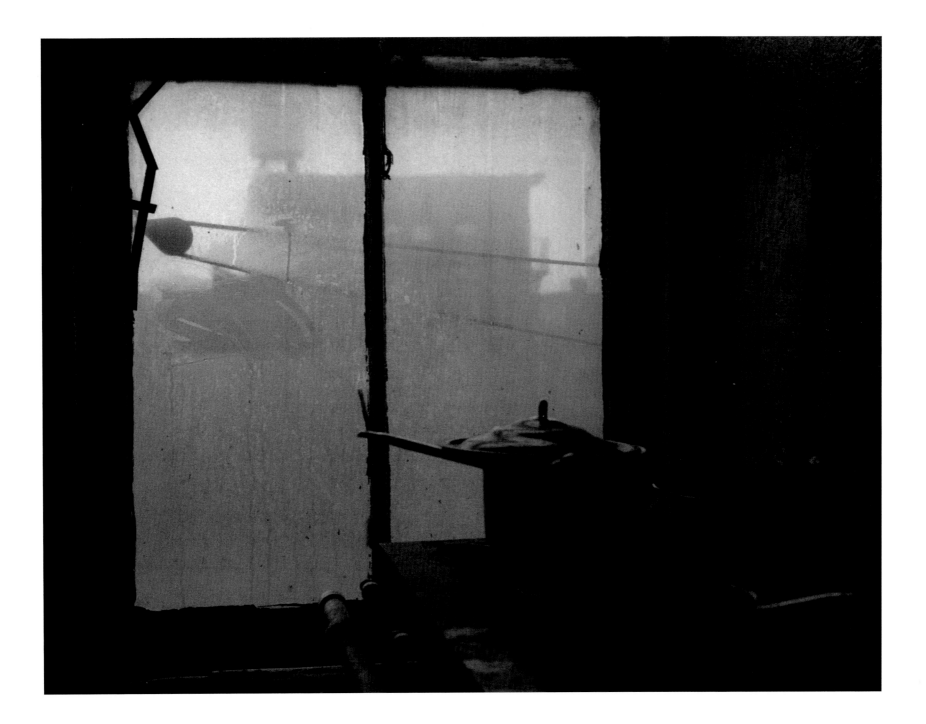

PLATE 11 117th Street, New York, 1951

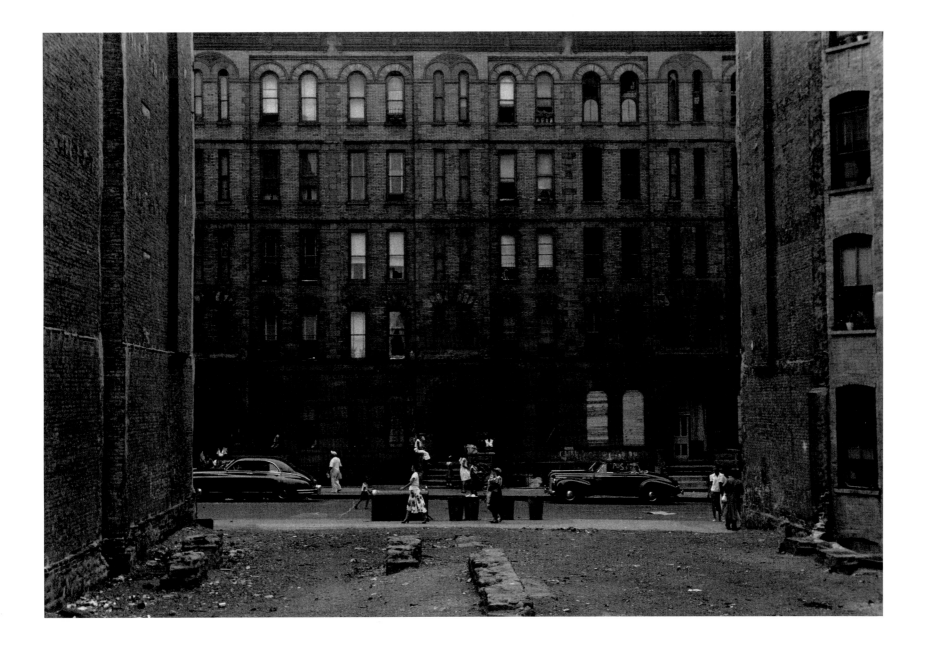

PLATE 12 Woman and children at intersection, New York, 1952

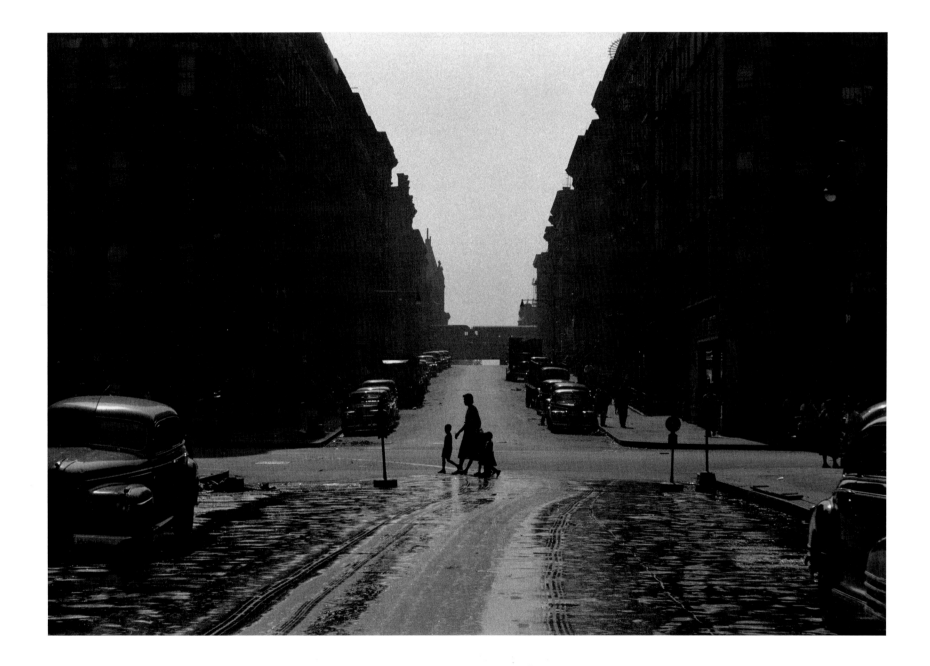

PLATE 13 Stickball, New York, 1952

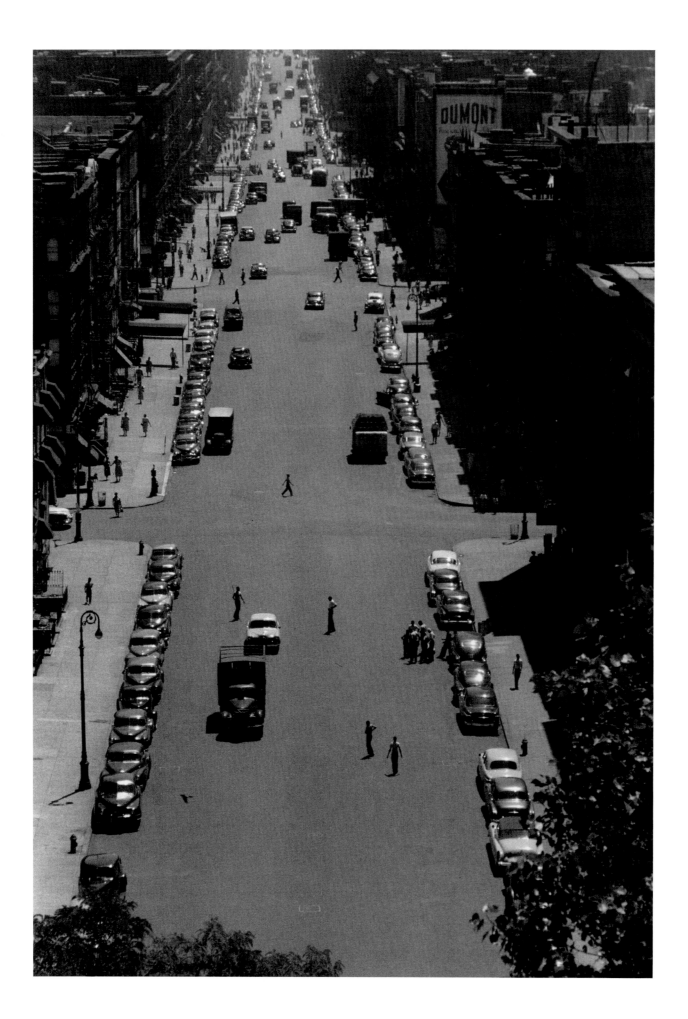

PLATE 14 Sun and shade, New York, 1952

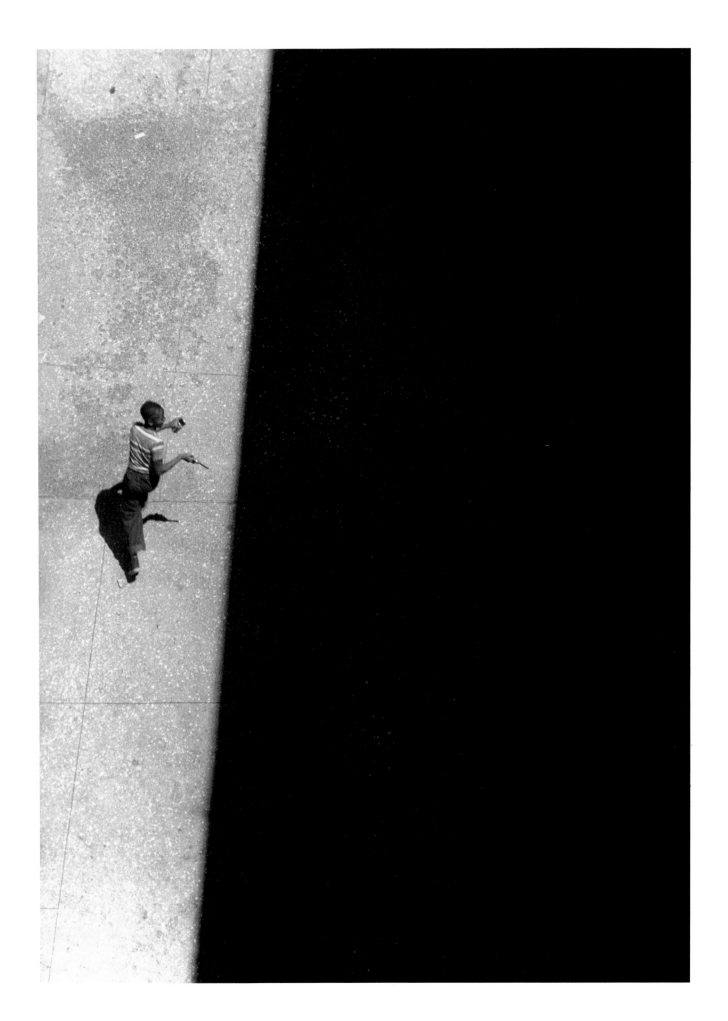

PLATE 15 Woman resting, subway entrance, New York, 1952

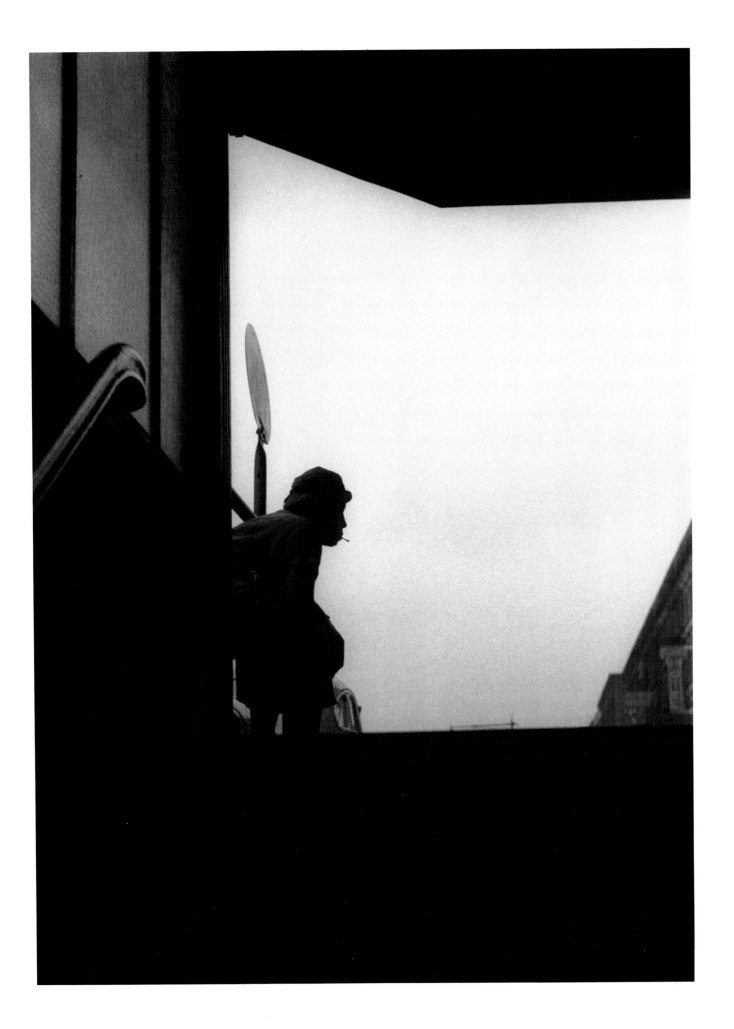

PLATE 16 Man on elevated, New York, 1952

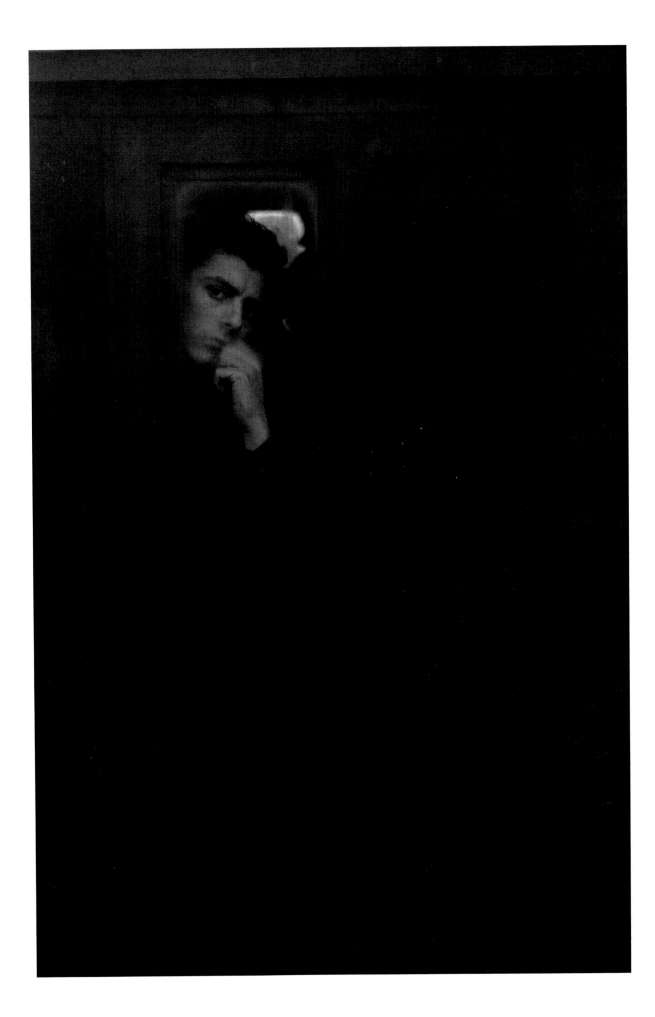

PLATE 17 7th Avenue Express, New York, 1952

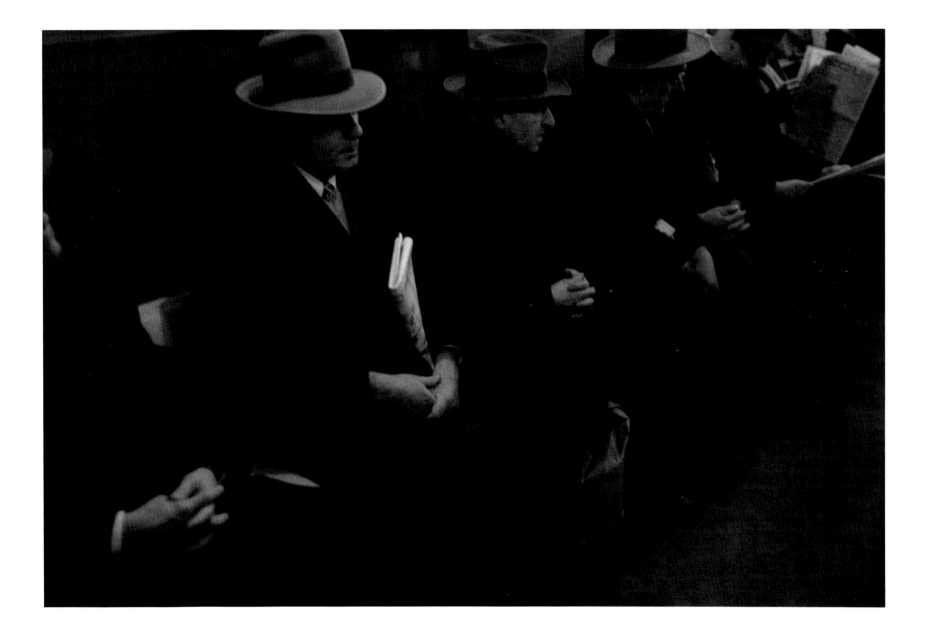

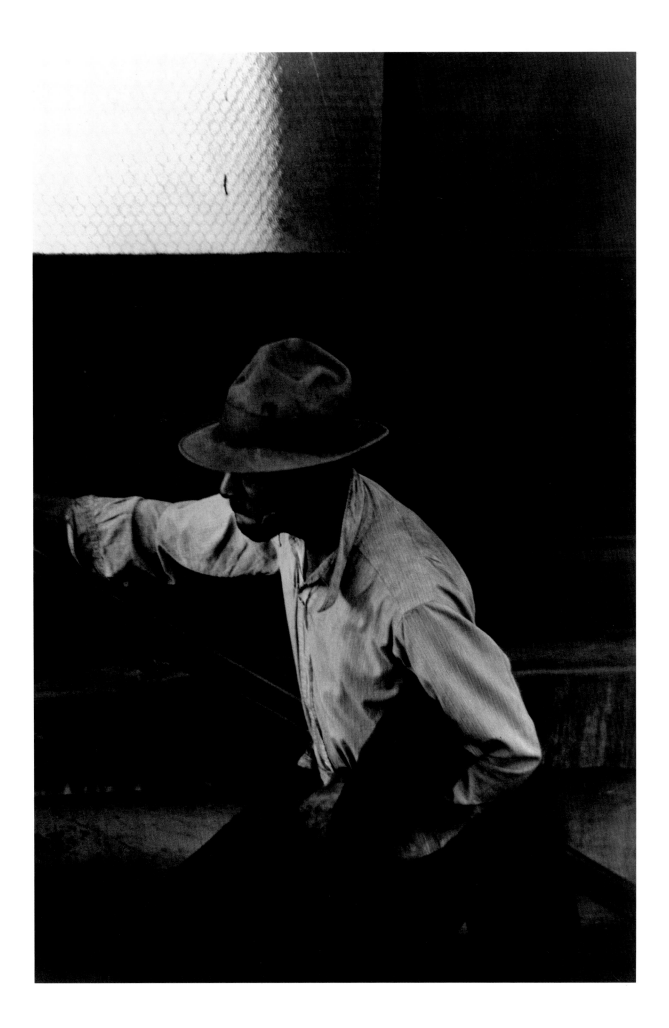

PLATE 19 David, New York, 1952

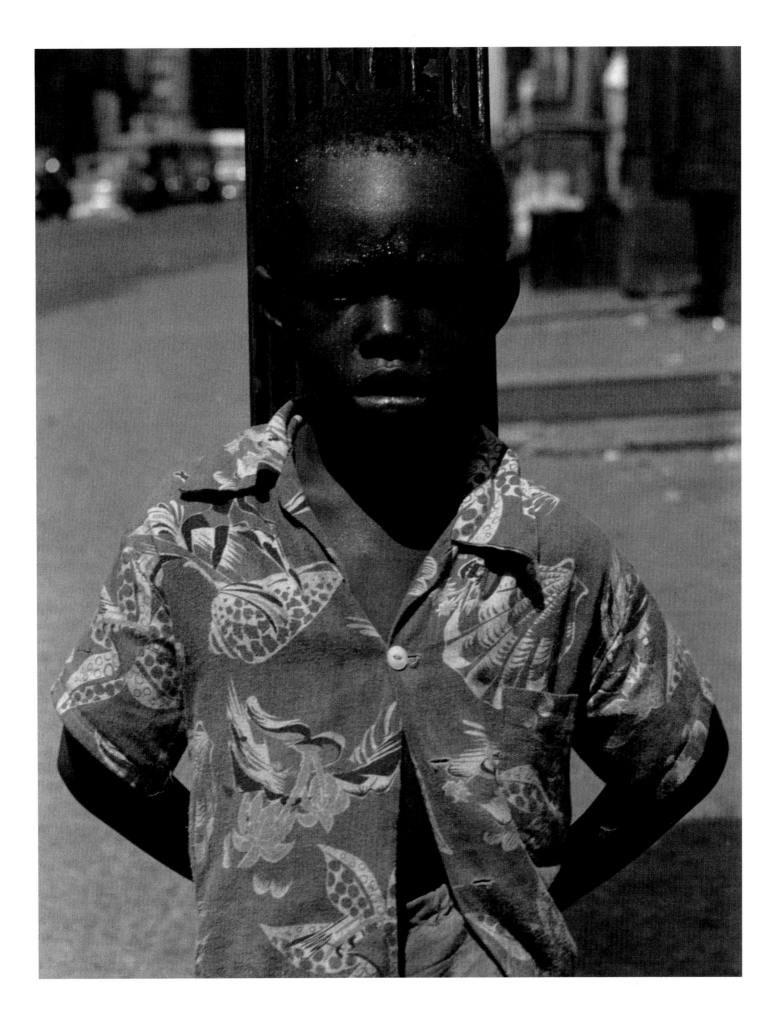

PLATE 20 Broken railing, New York, 1952

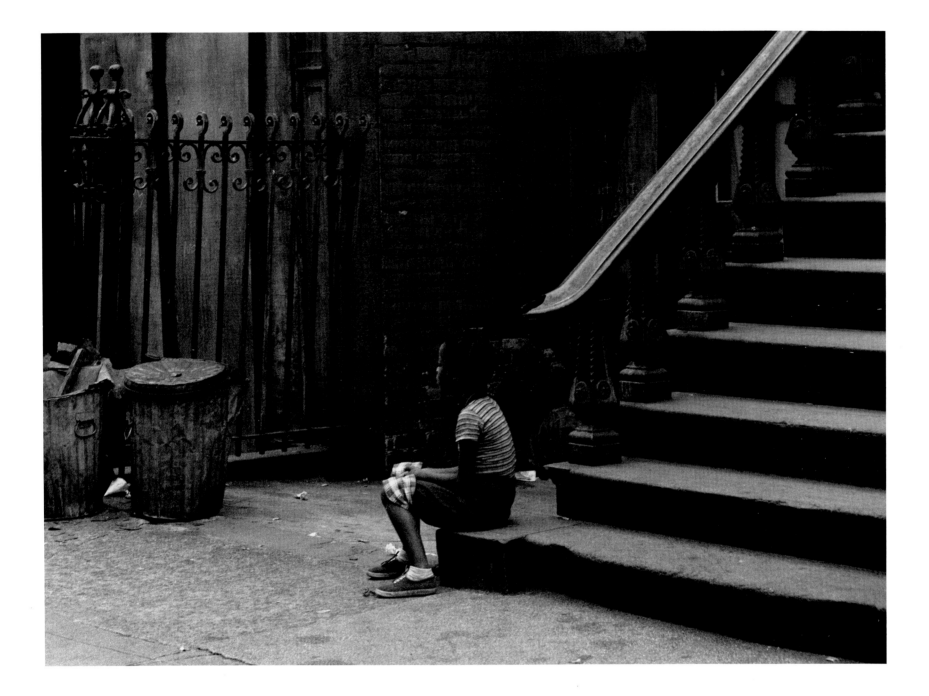

PLATE 21　Shirley looking down stairwell, New York, 1952

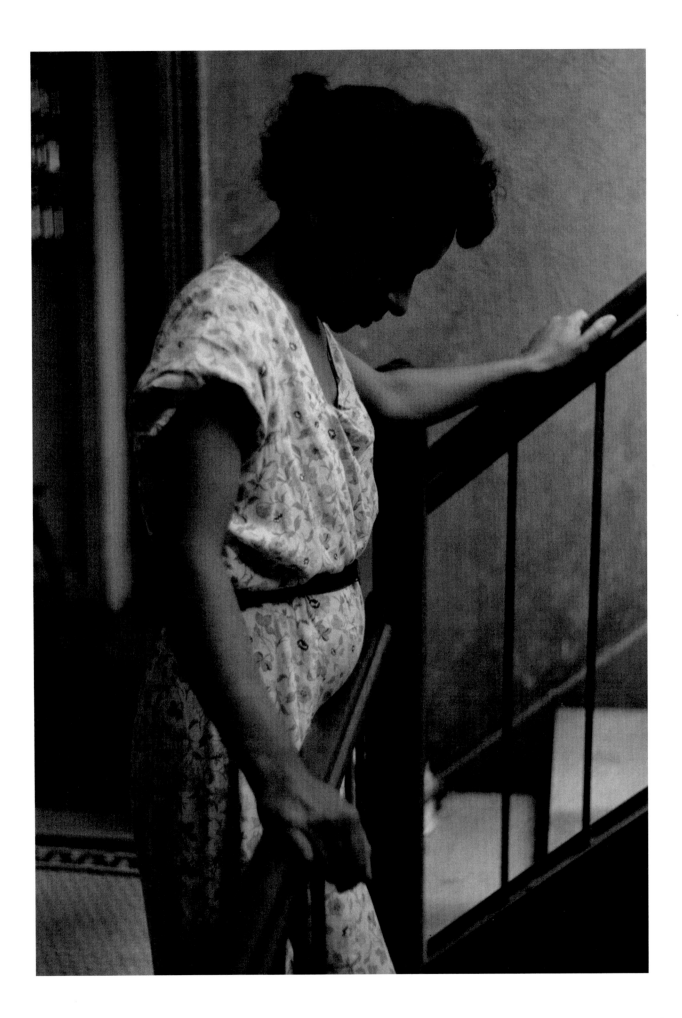

PLATE 22 Sam laughing, New York, 1952

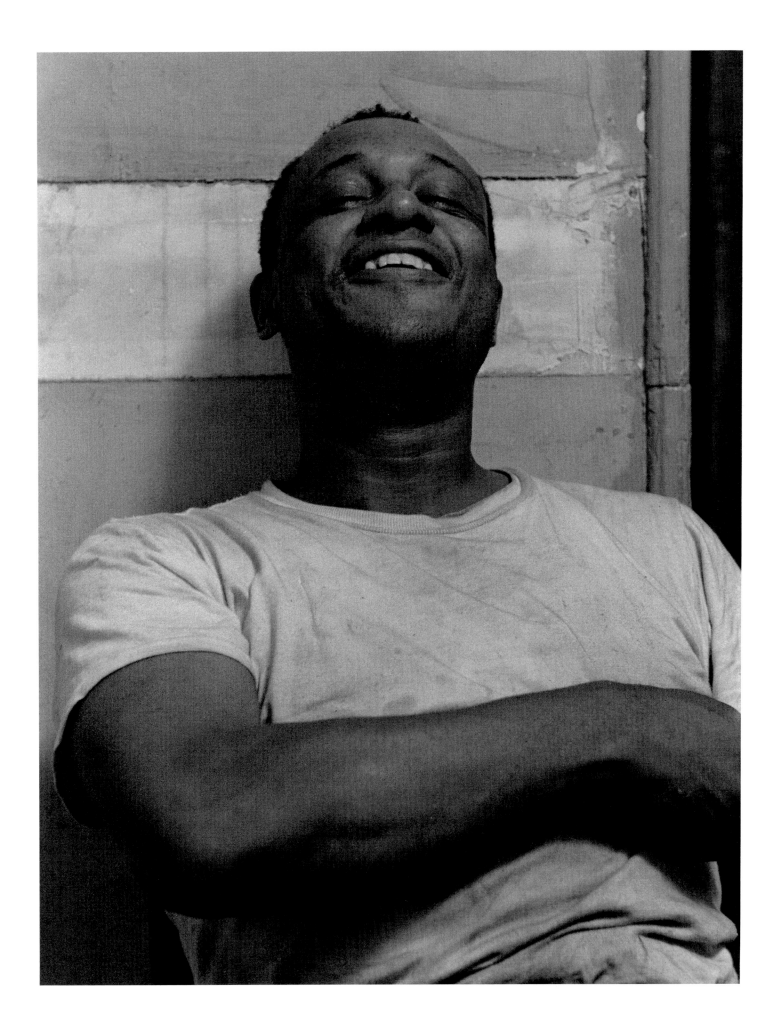

PLATE 23 Joe and the twins, New York, 1952

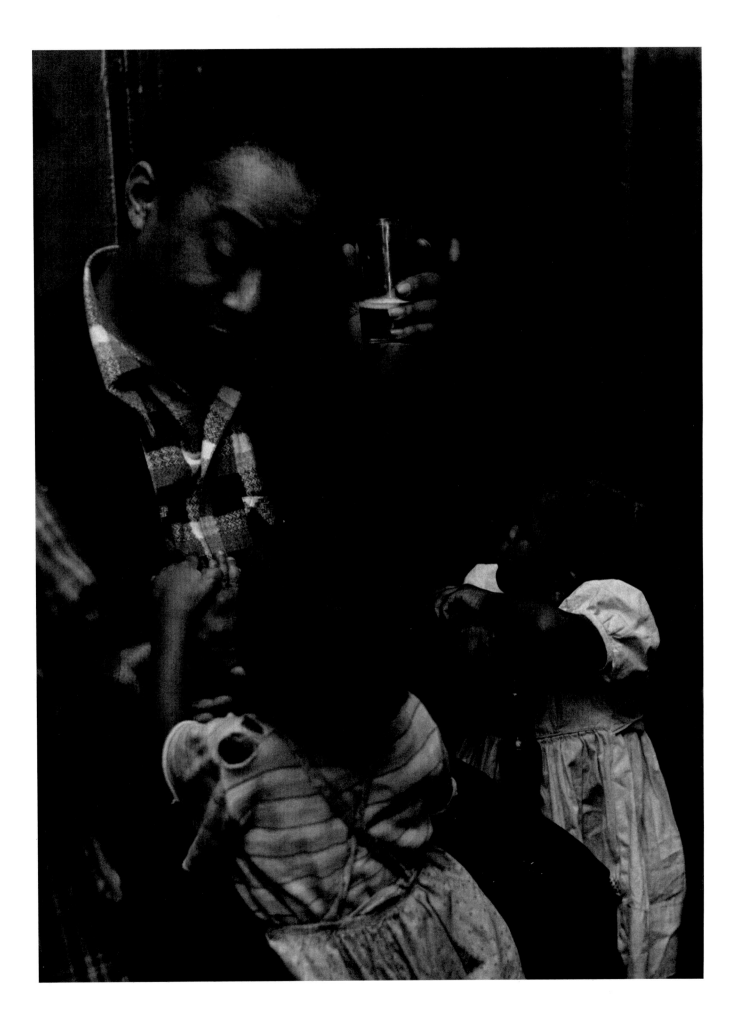

PLATE 24 Graham, New York, 1952

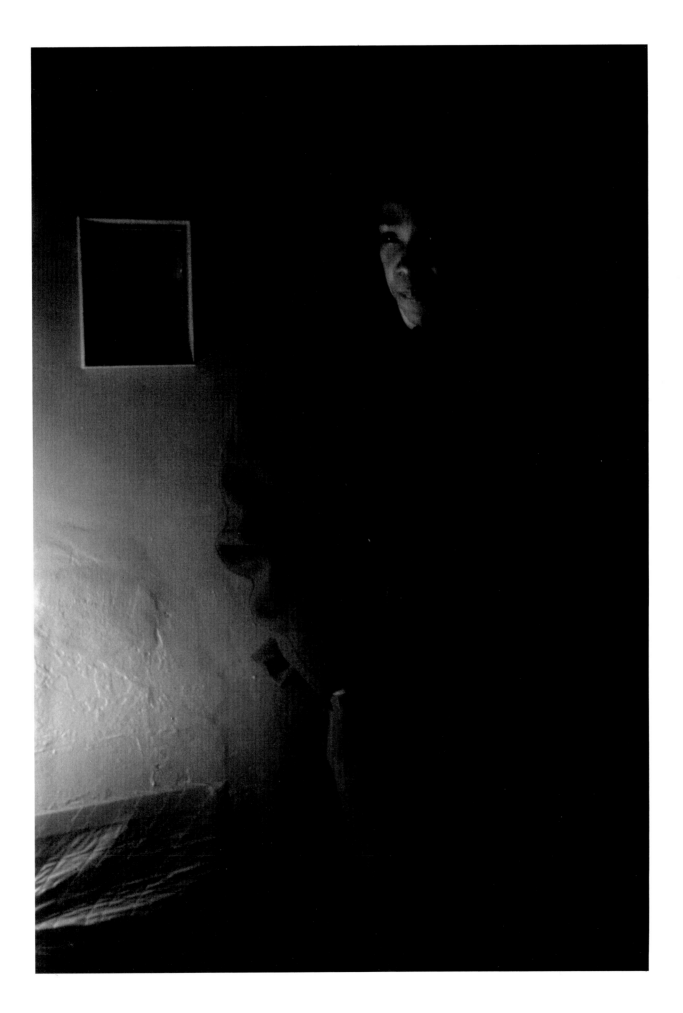

PLATE 25 Catsup bottles, table and coat, New York, 1952

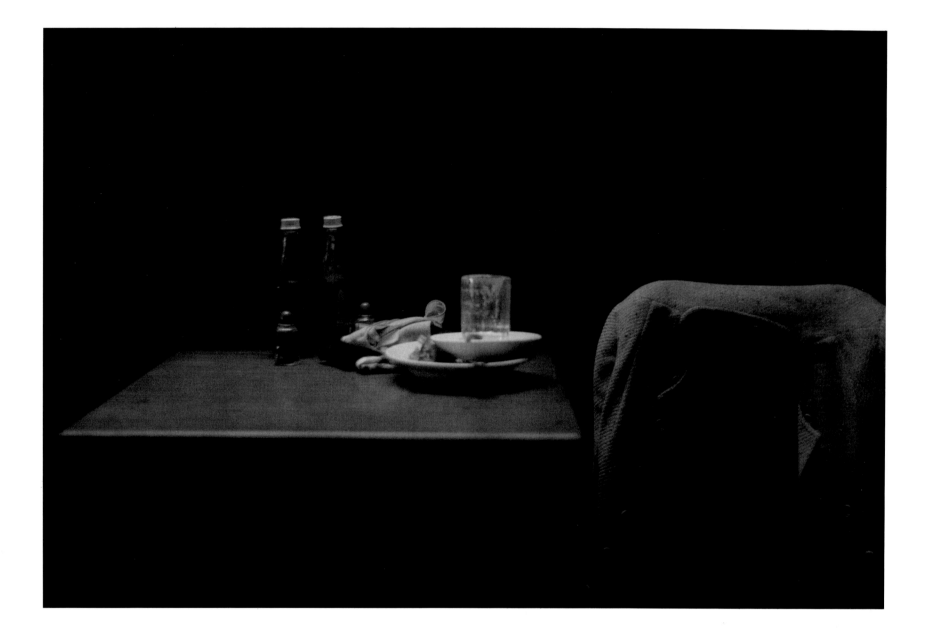

PLATE 26 Hallway, New York, 1953

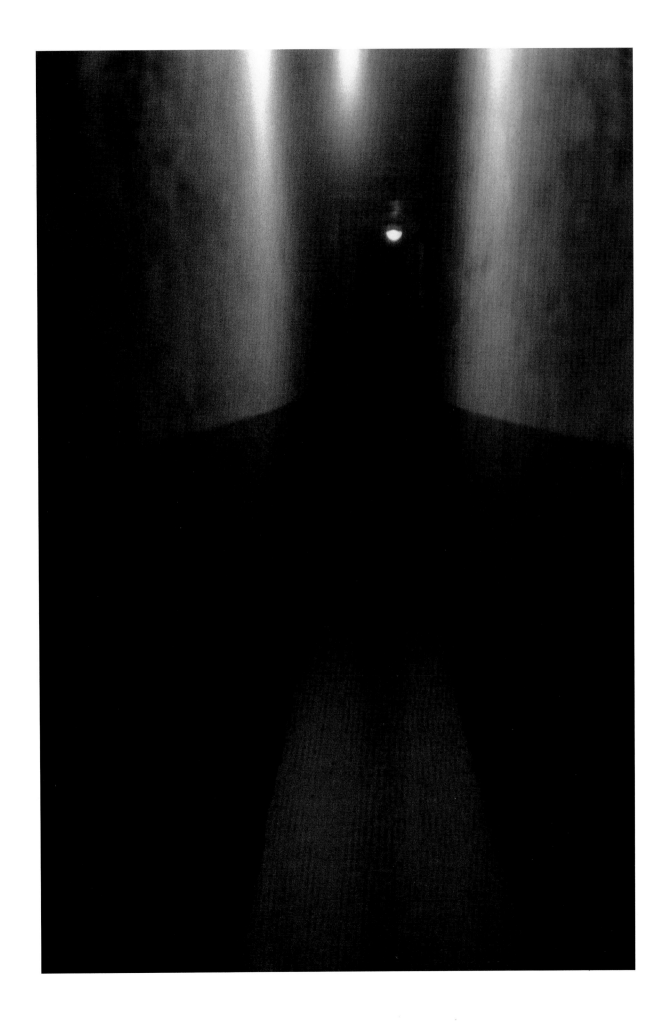

PLATE 27 Two boys playing on sidewalk, night, New York, 1953

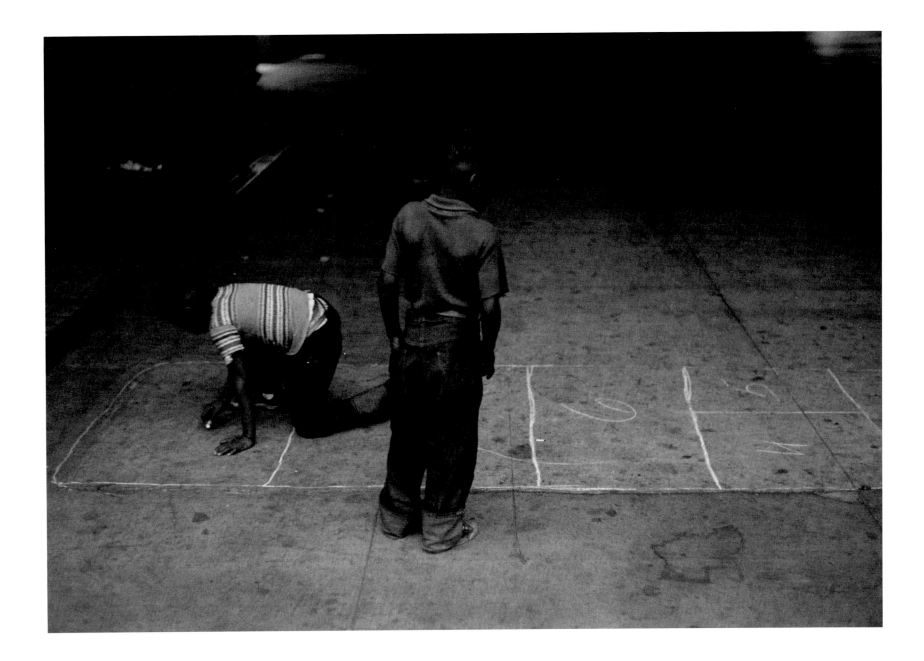

PLATE 28 Out of order, New York, 1953

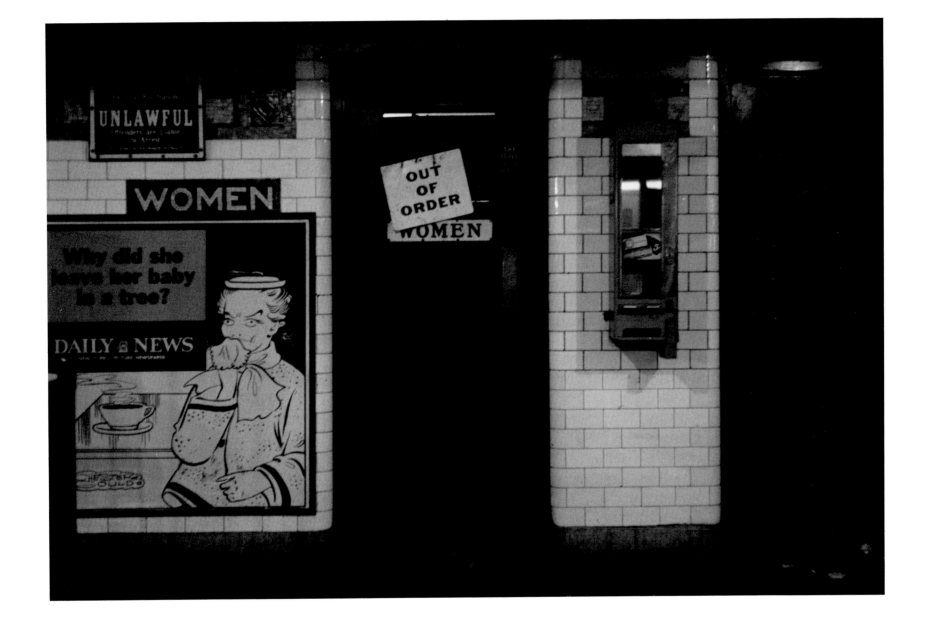

PLATE 29 Subway stairs, two men, New York, 1954

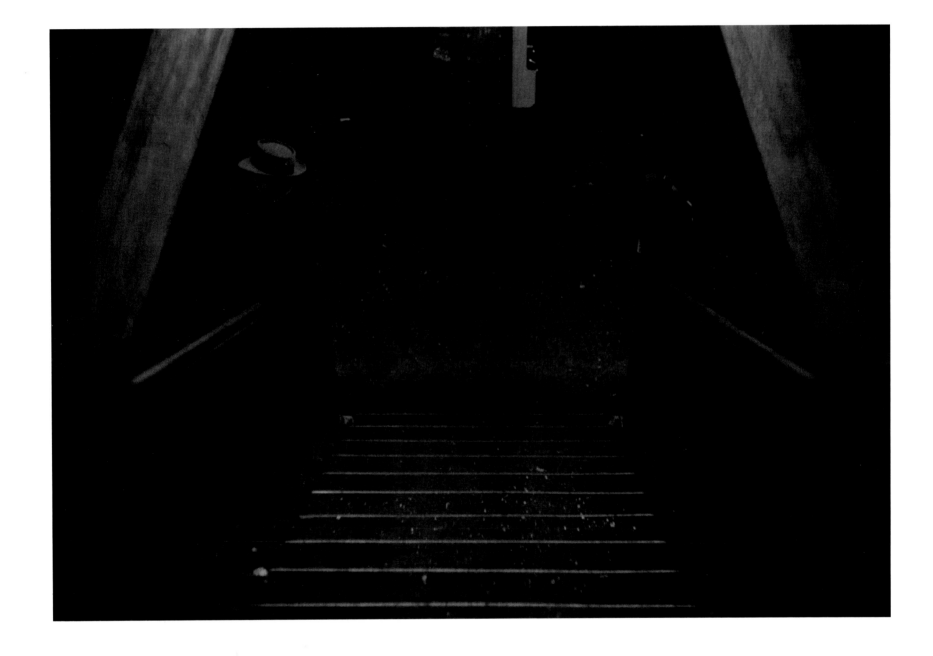

PLATE 30　Woman on bench at night, New York, 1956

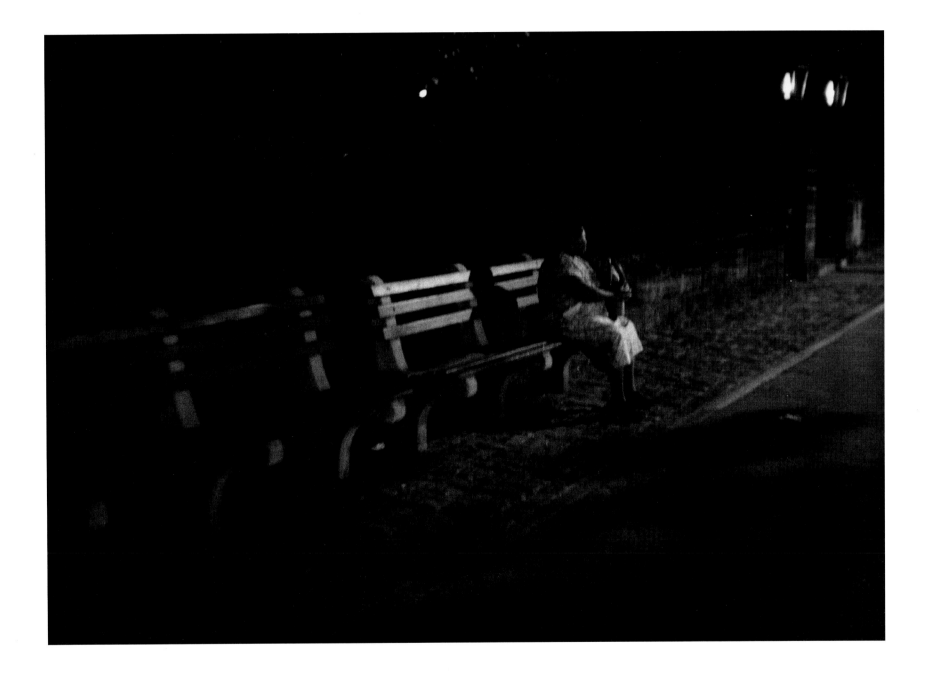

PLATE 31 Haynes, Jones and Benjamin, New York, 1956

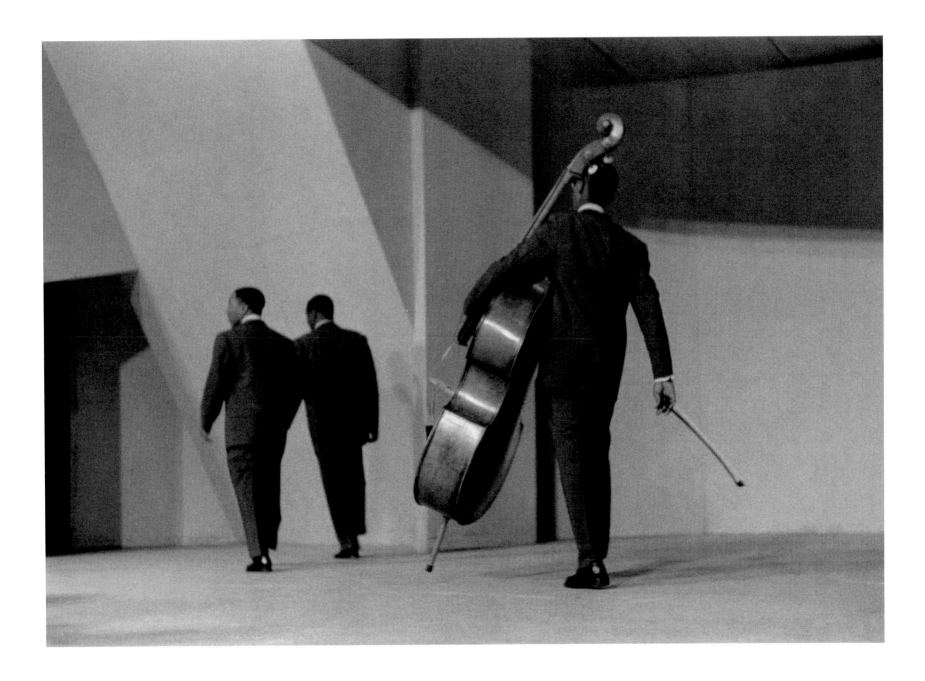

PLATE 32 Dancers, New York, 1956

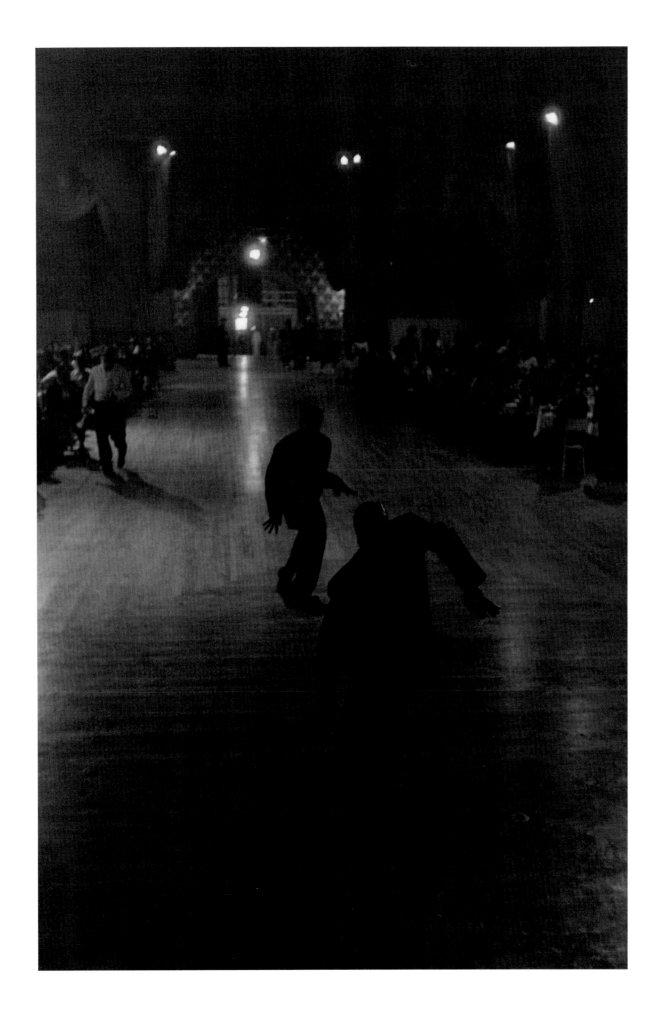

PLATE 33 Couple dancing, New York, 1956

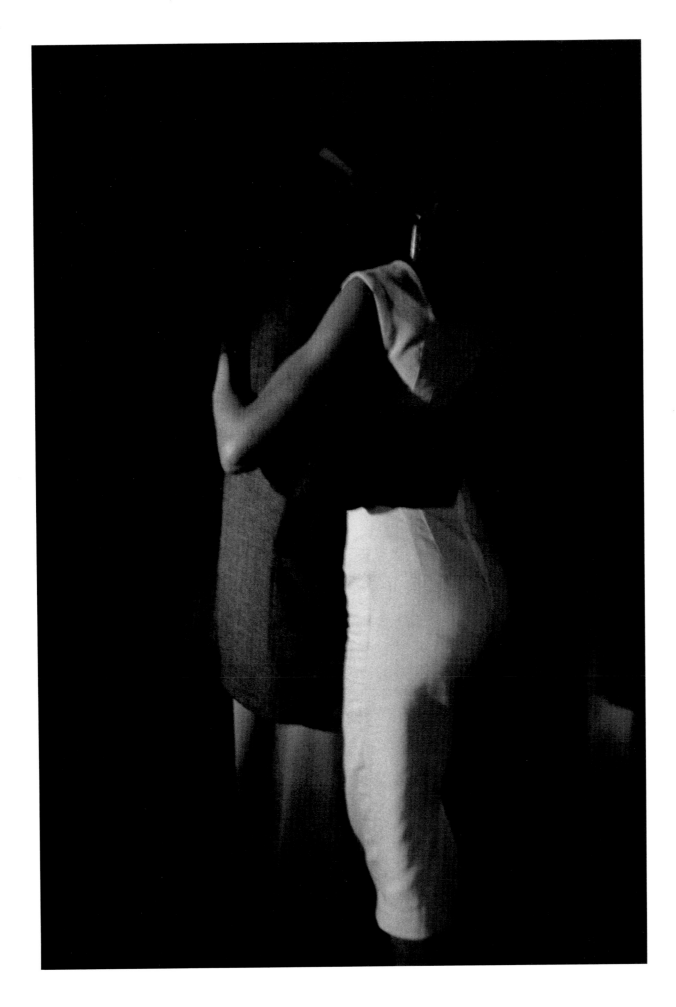

PLATE 34 Milt Jackson, New York, 1956

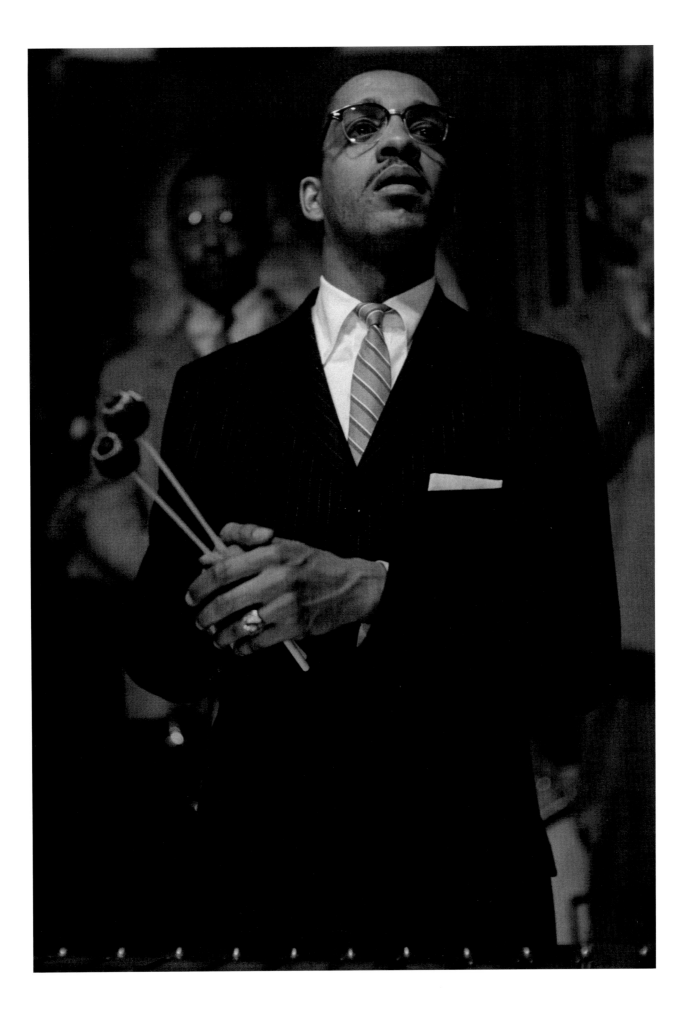

PLATE 35 Man with two shovels, New York, 1959

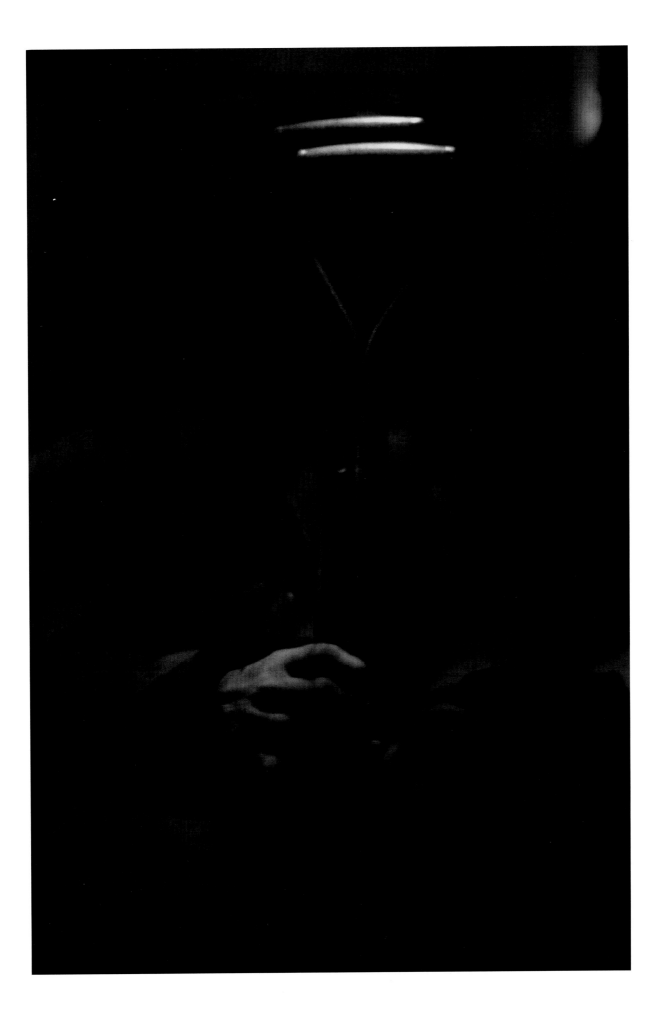

PLATE 36　White line, New York, 1960

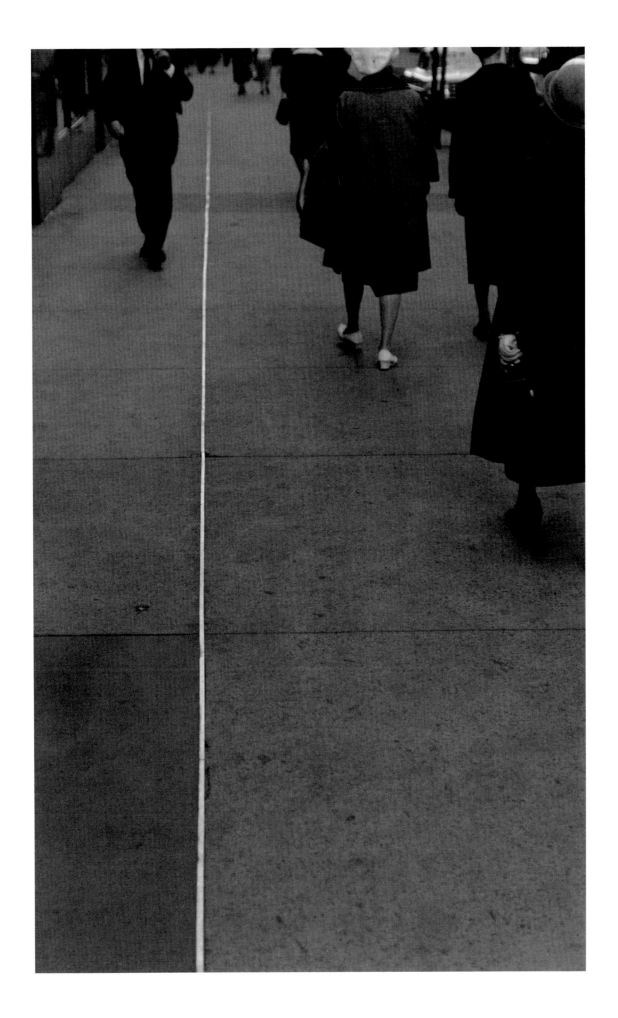

PLATE 37 Couple walking, Park Avenue, New York, 1960

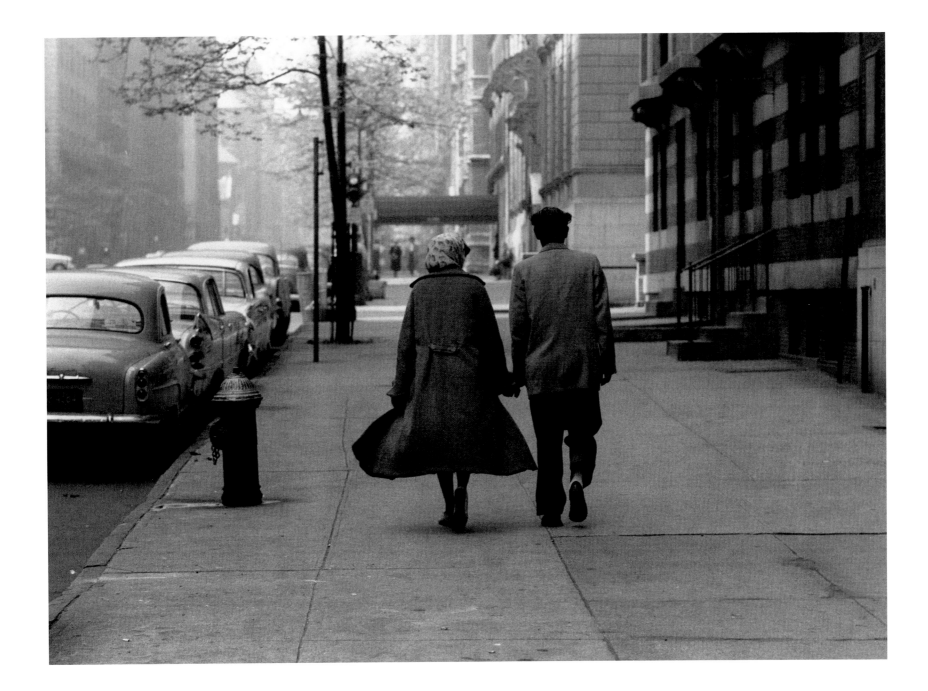

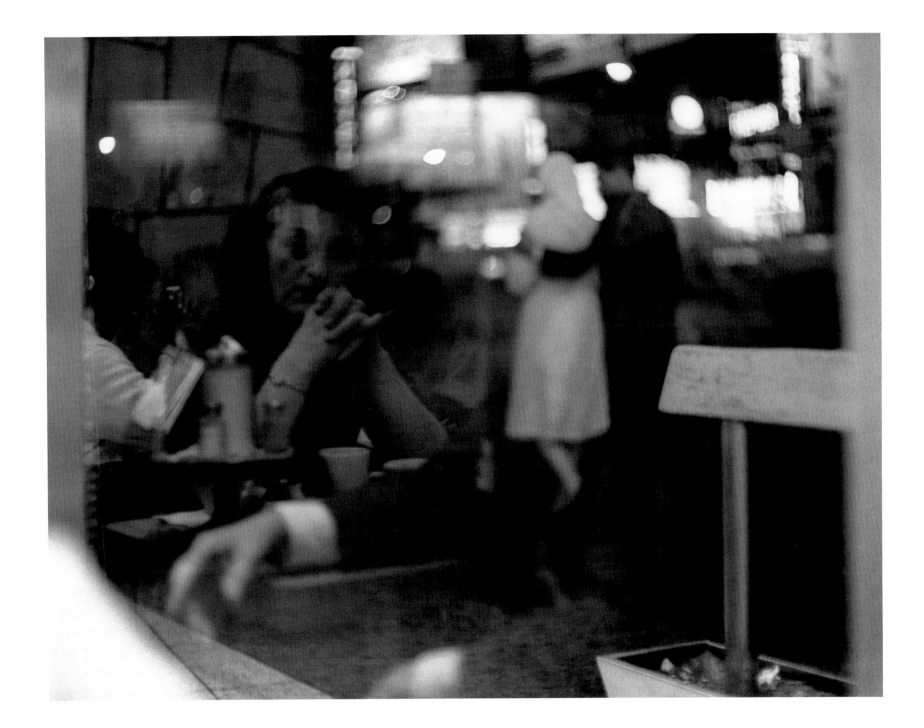

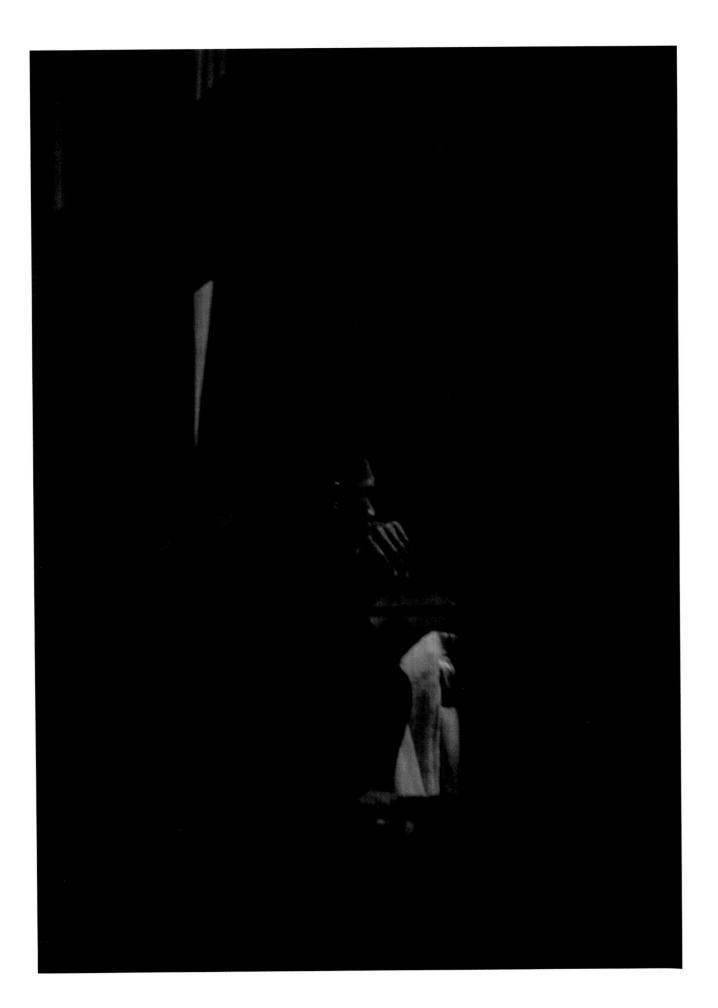

PLATE 40 Coltrane and Elvin, New York, 1960

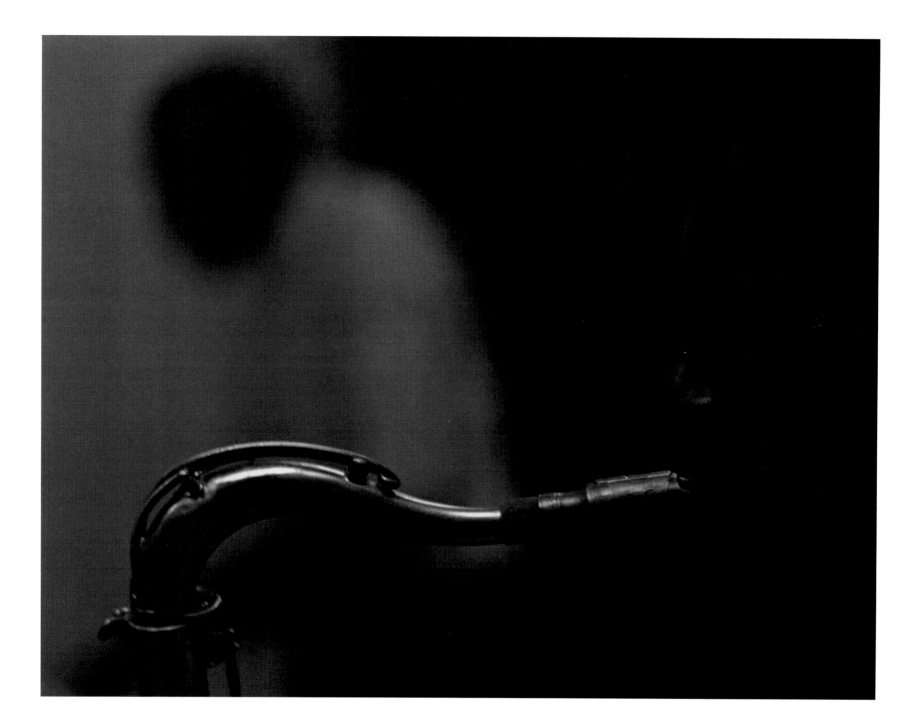

PLATE 41 Elvin Jones, New York, 1961

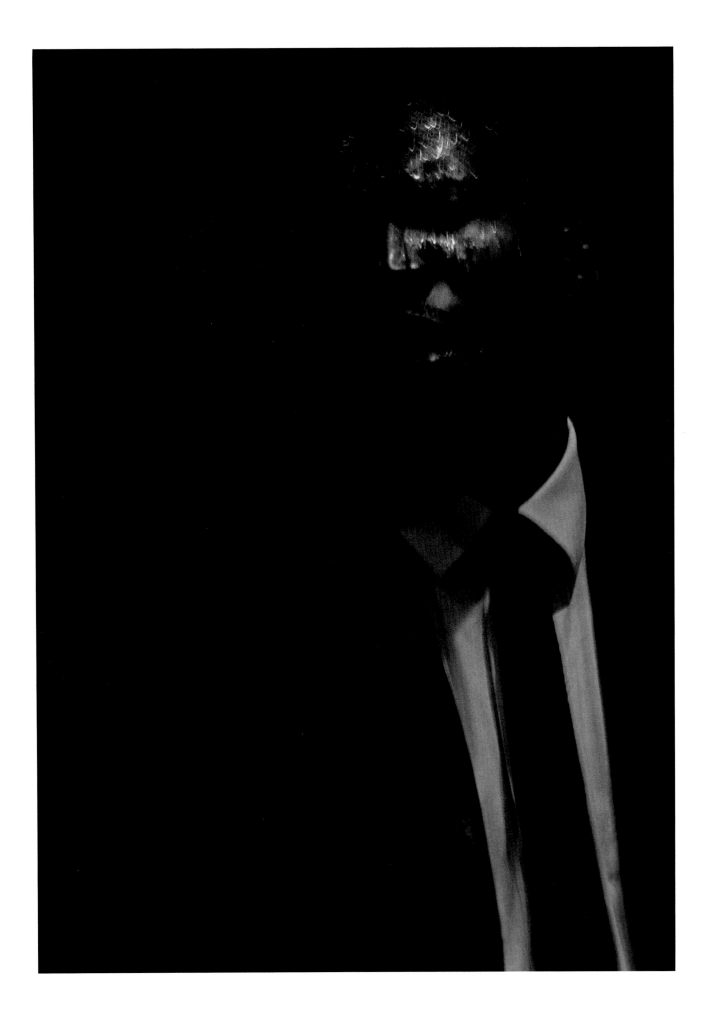

PLATE 42　Ex-fighter, New York, 1961

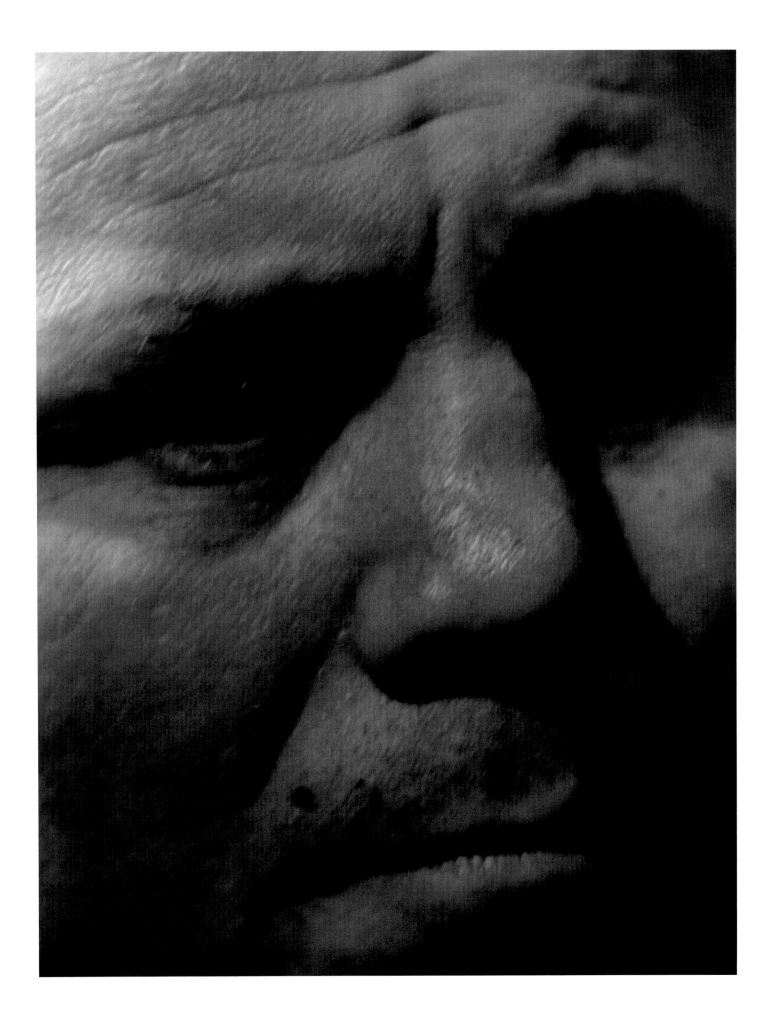

PLATE 43 Coathanger, New York, 1961

PLATE 44 Between cars, New York, 1961

PLATE 45 White car and dots, New York, 1961

PLATE 46 Cab 173, New York, 1962

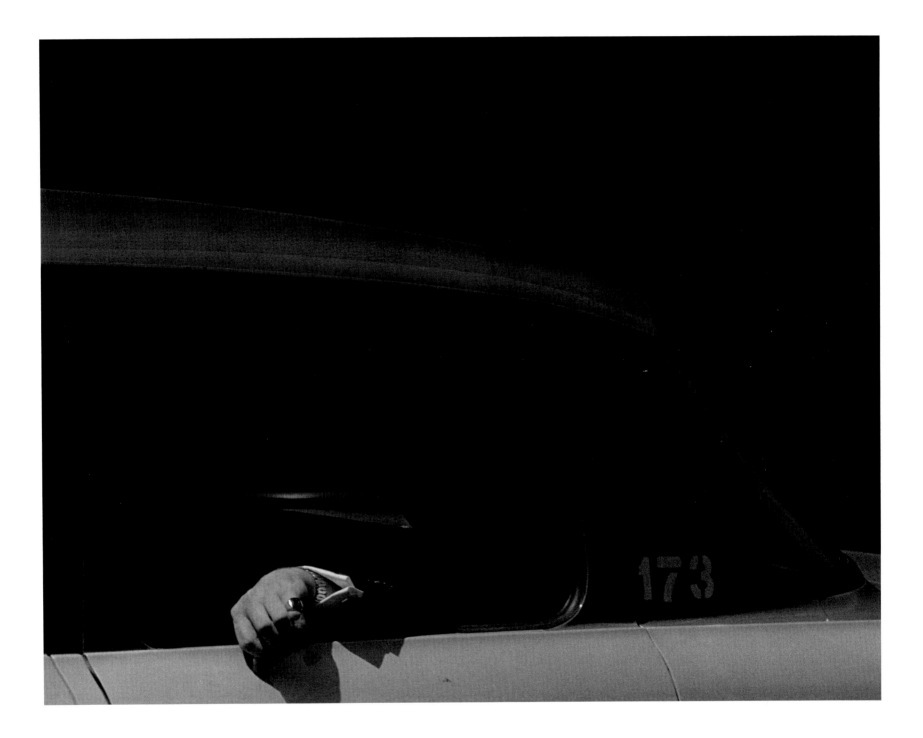

PLATE 47 Hotel, New York, 1962

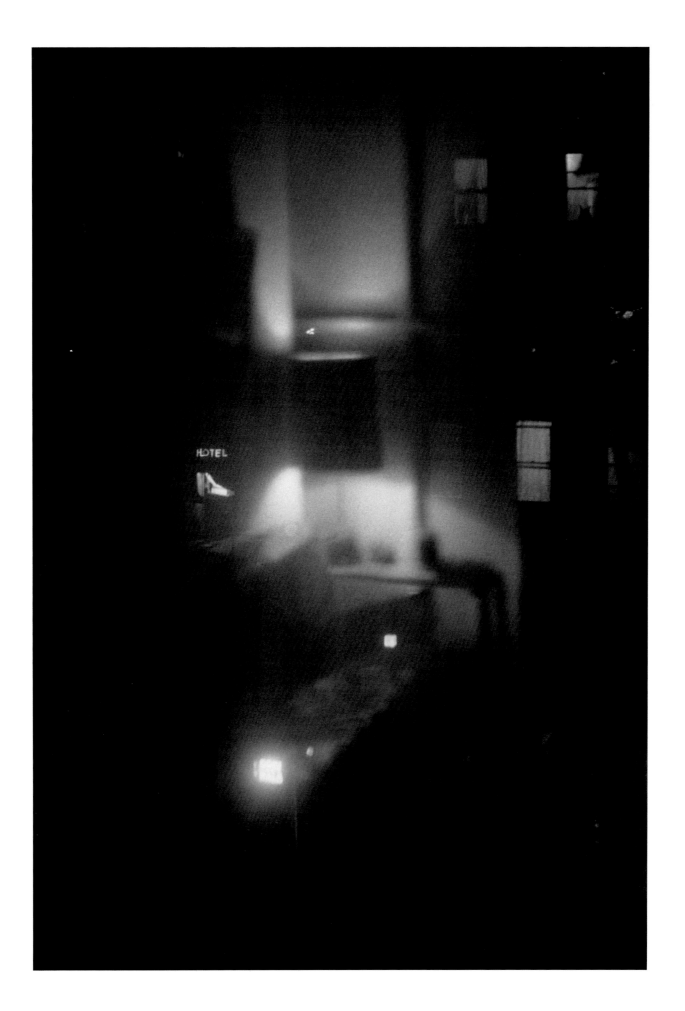

PLATE 48 Bill and son, New York, 1962

PLATE 50 Woman in sandals, Washington, D. C., 1963

PLATE 51 This site, New York, 1963

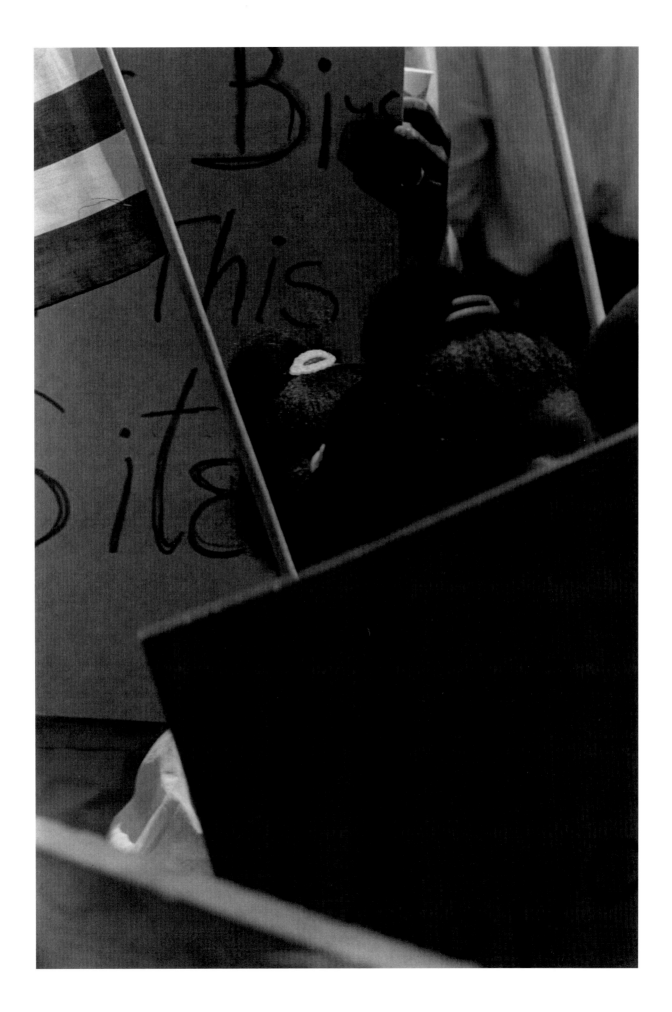

PLATE 52 Force, New York, 1963

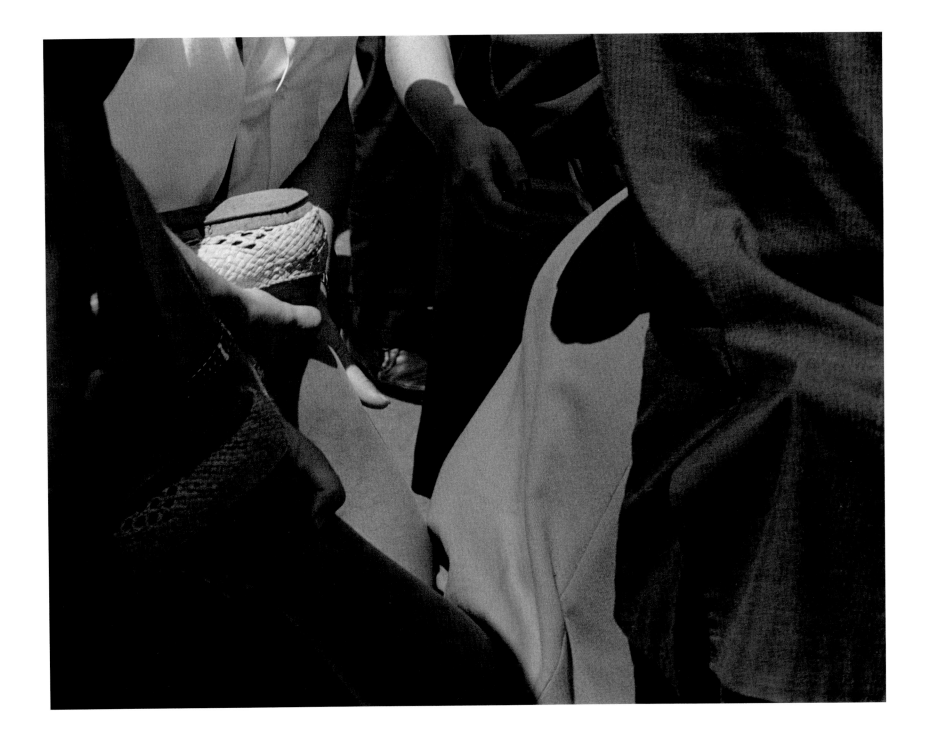

PLATE 53 Horace Silver, New York, 1963

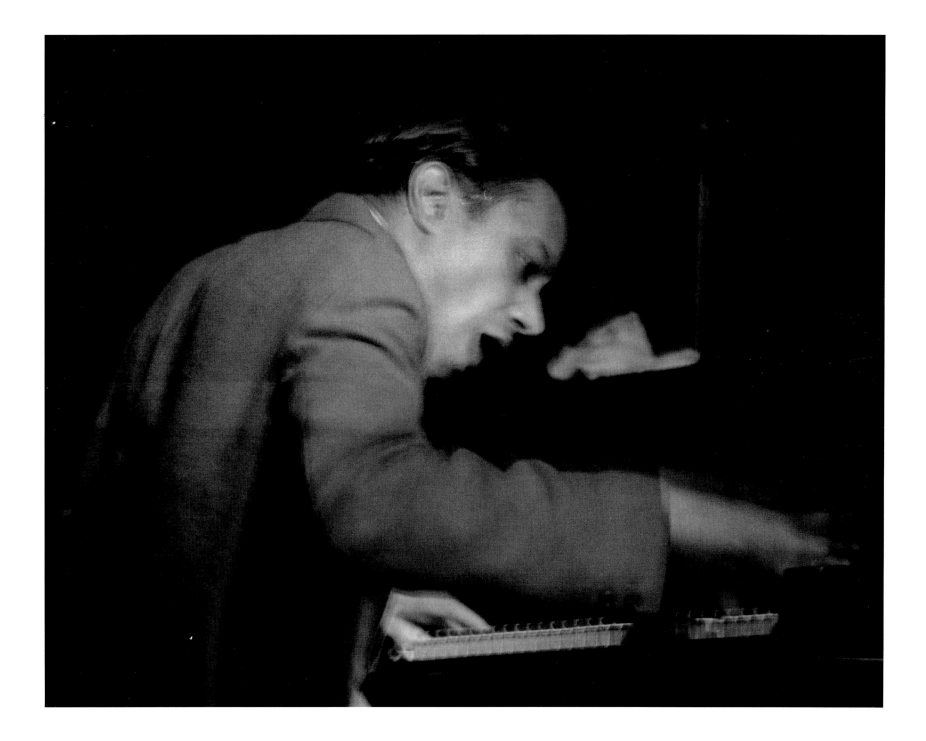

PLATE 54 Coltrane on soprano, New York, 1963

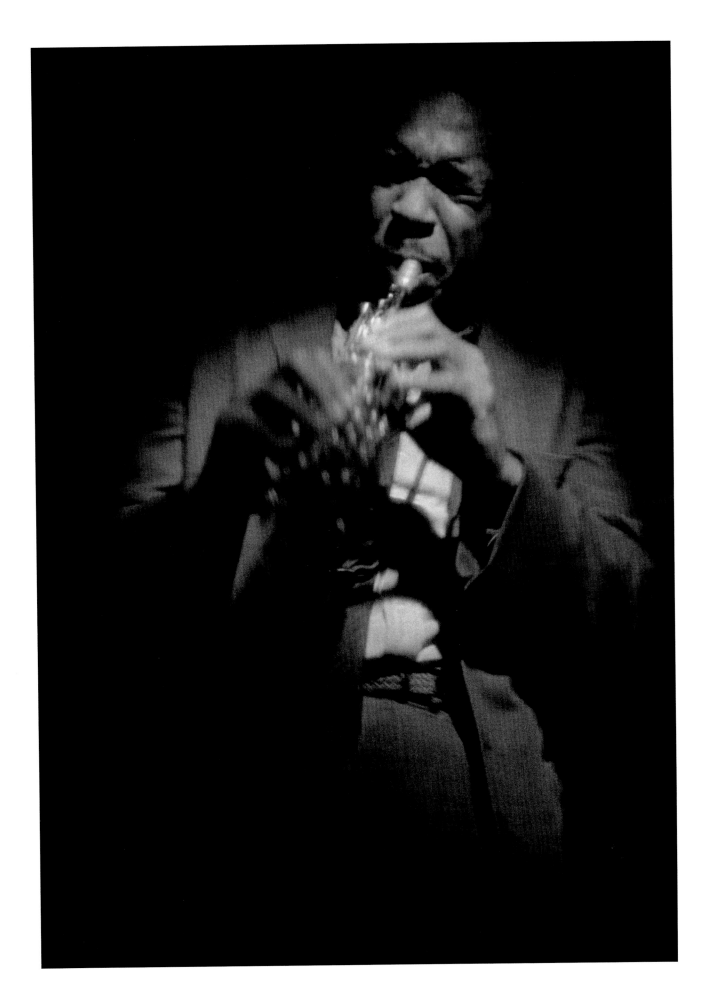

PLATE 55 Couple and lady, Bryant Park, New York, 1963

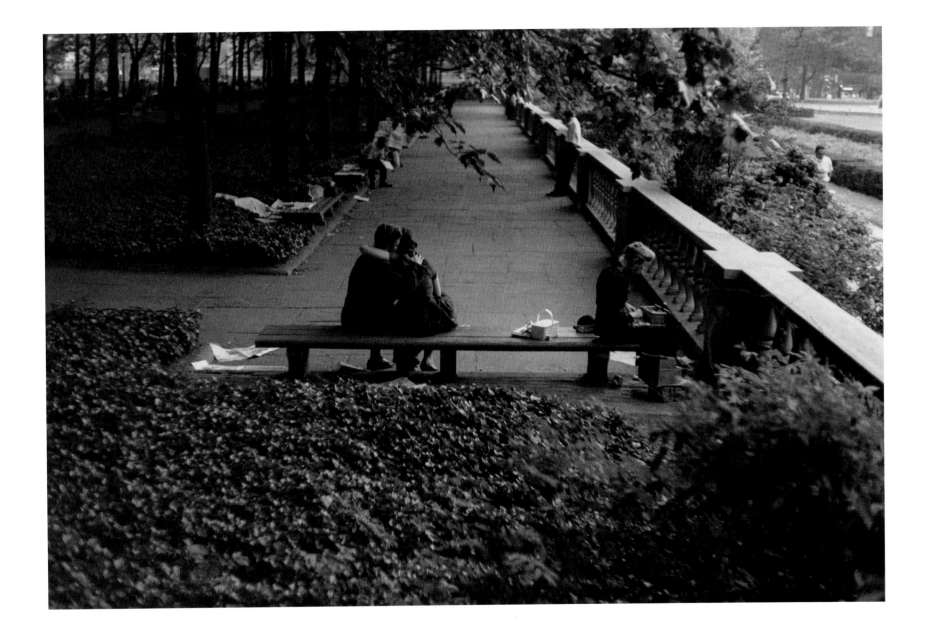

PLATE 56 Man leaning on post, truck, New York, 1963

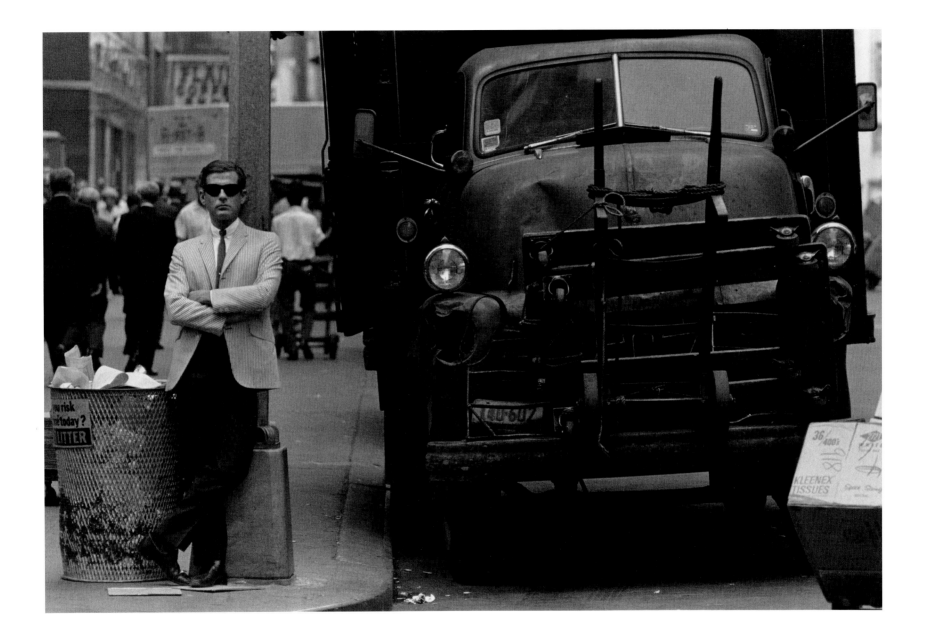

PLATE 57 Three men with hand trucks, New York, 1963

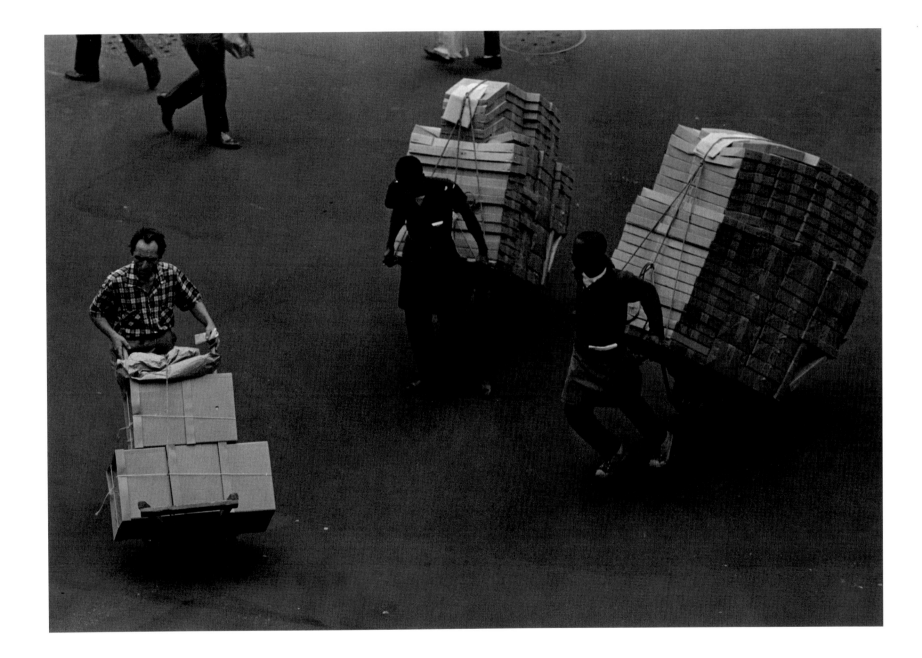

PLATE 58 Two men leaning on posts, New York, 1964

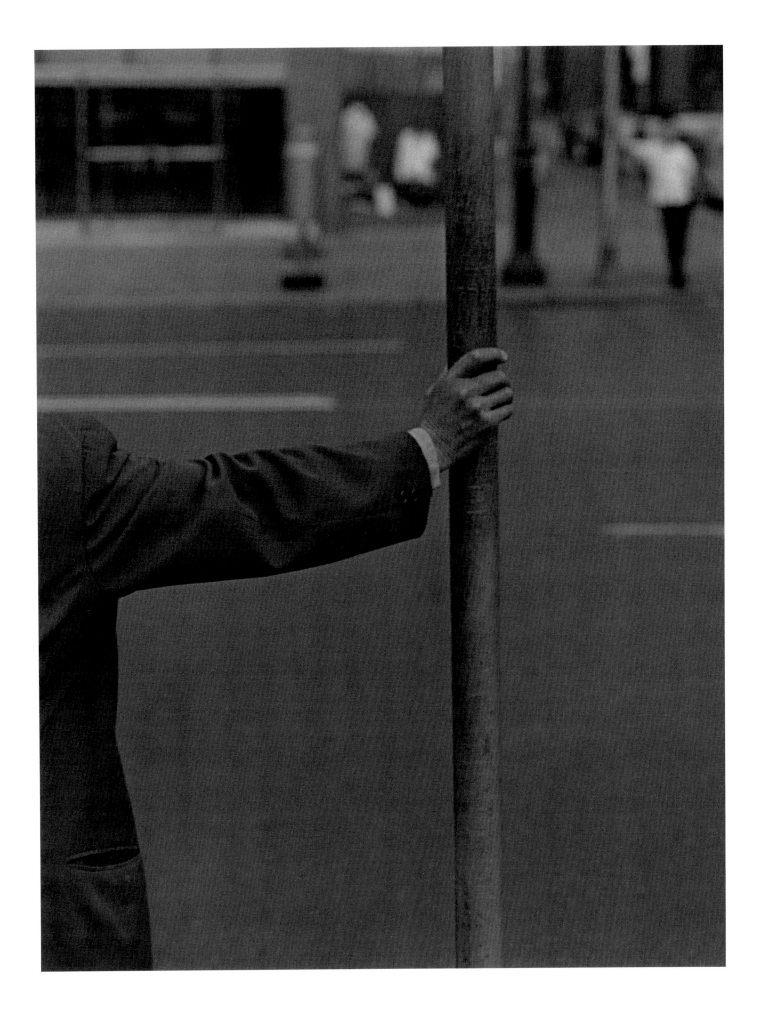

PLATE 59 Subway ceiling, New York, 1964

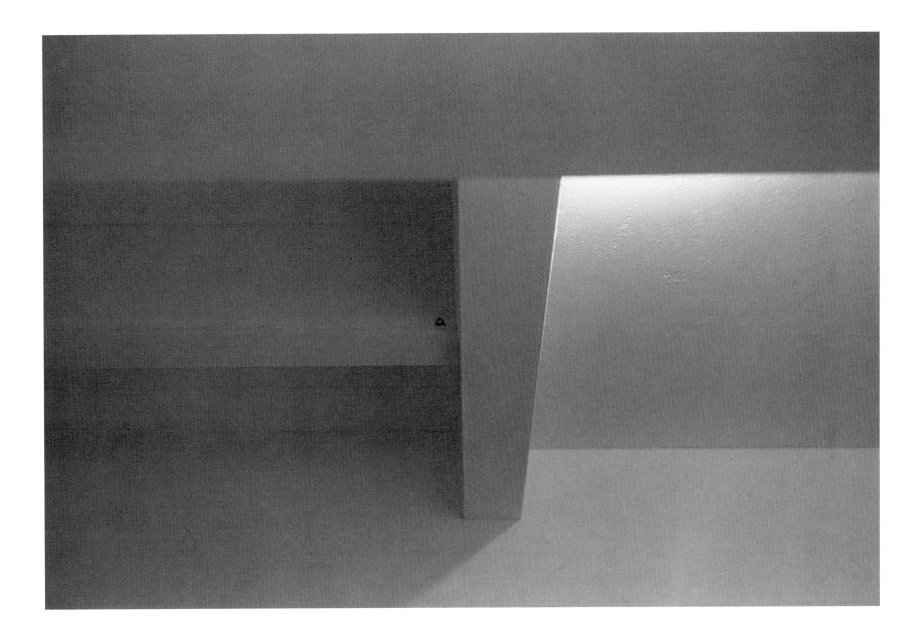

PLATE 60 Home for the aged, yard, New York, 1964

PLATE 61 Four men, New York, 1964

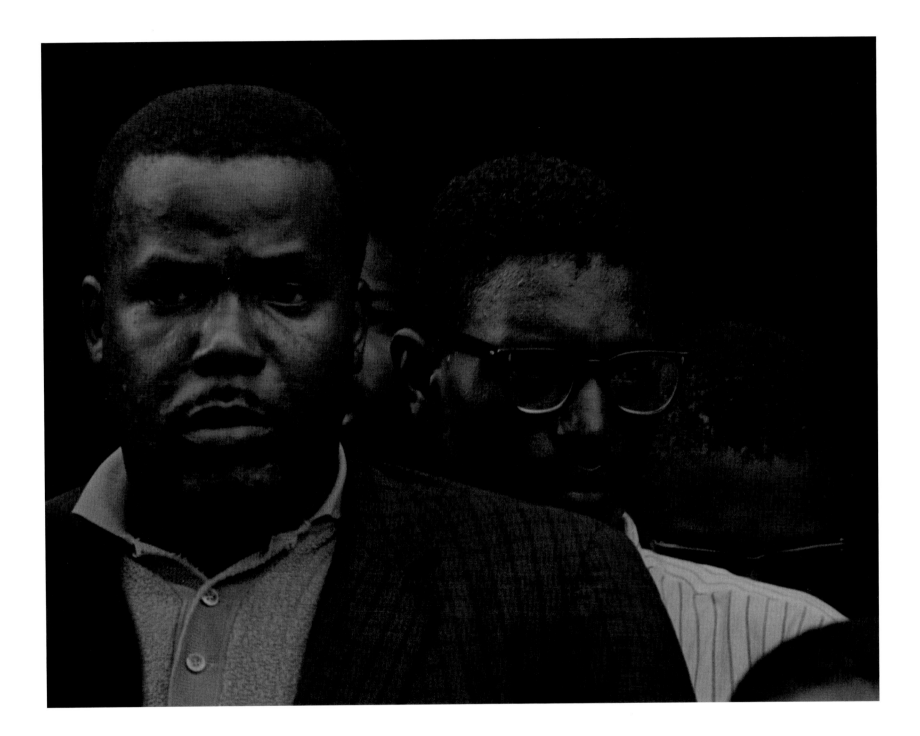

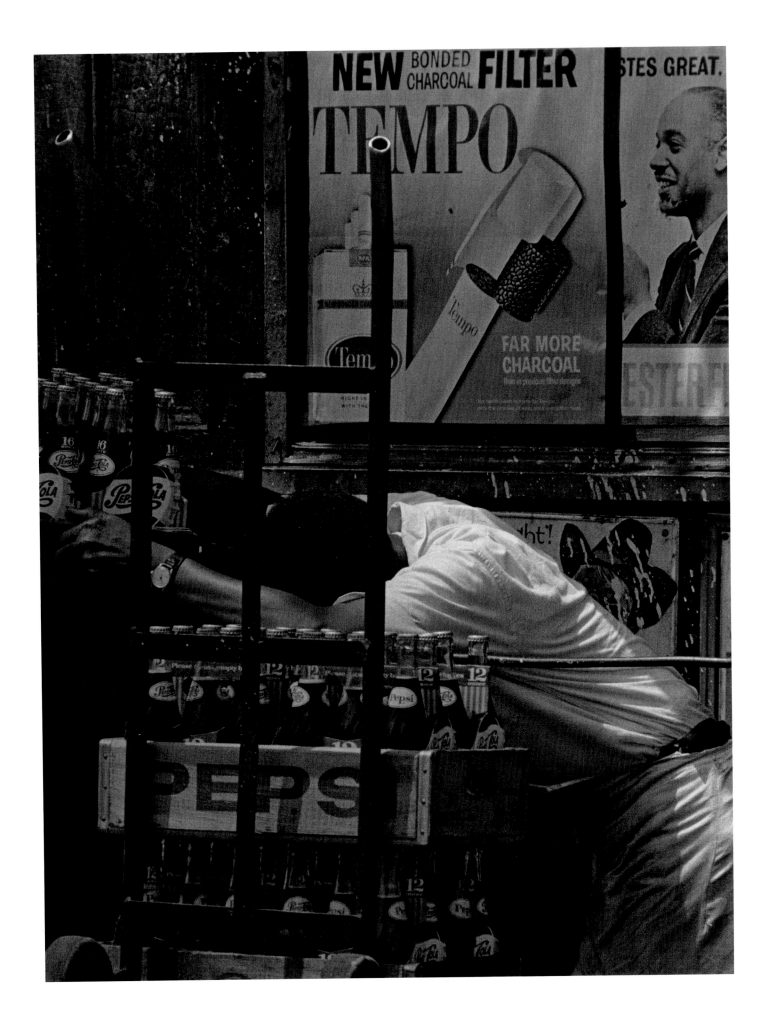

PLATE 63 Man sitting on cart, New York, 1966

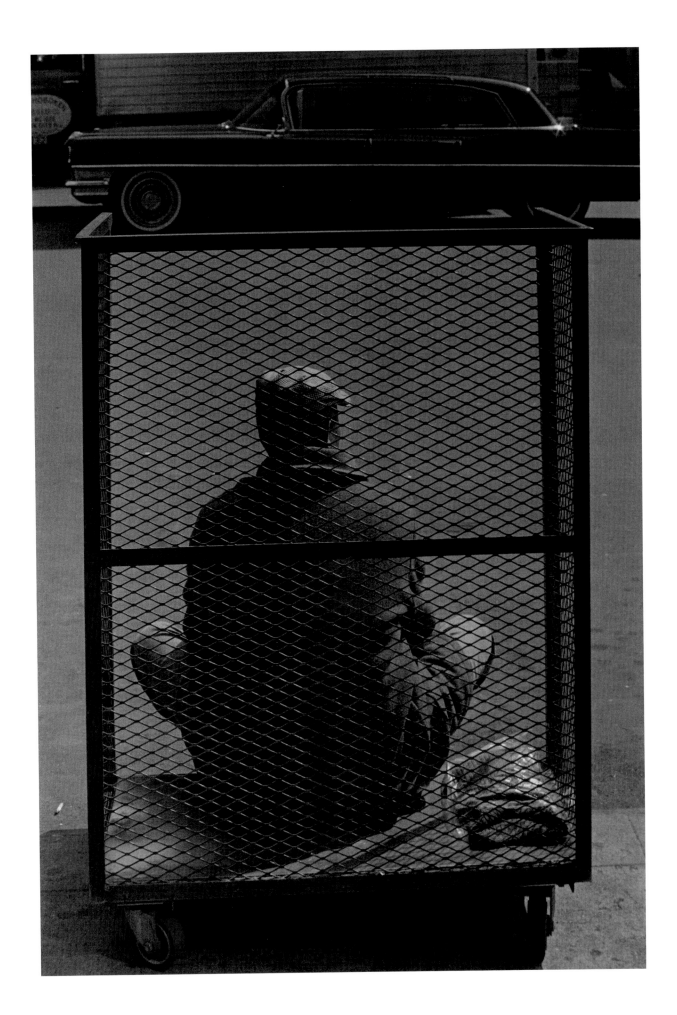

PLATE 64 Night feeding, New York, 1973

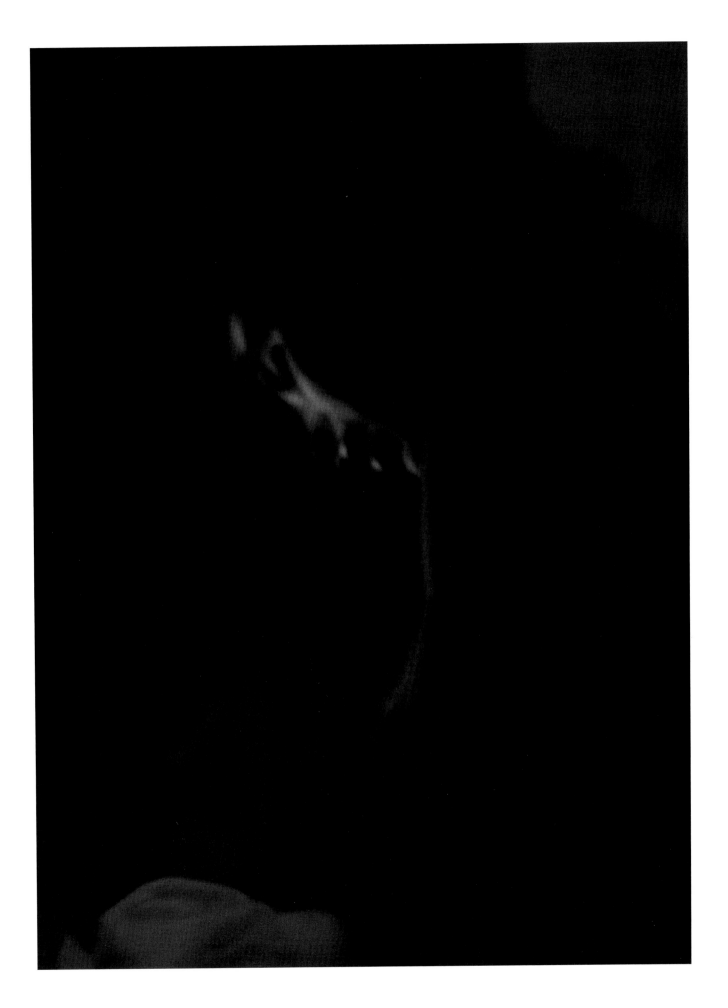

PLATE 65 Sherry and Susan, New York, 1974

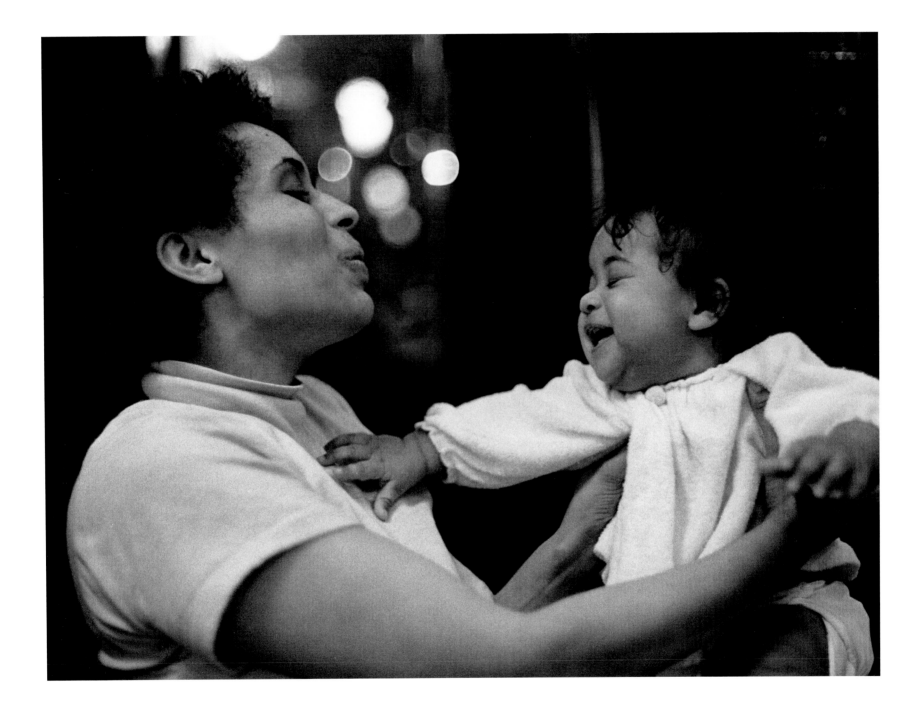

PLATE 66 Embroidered blouse, Washington, D. C., 1975

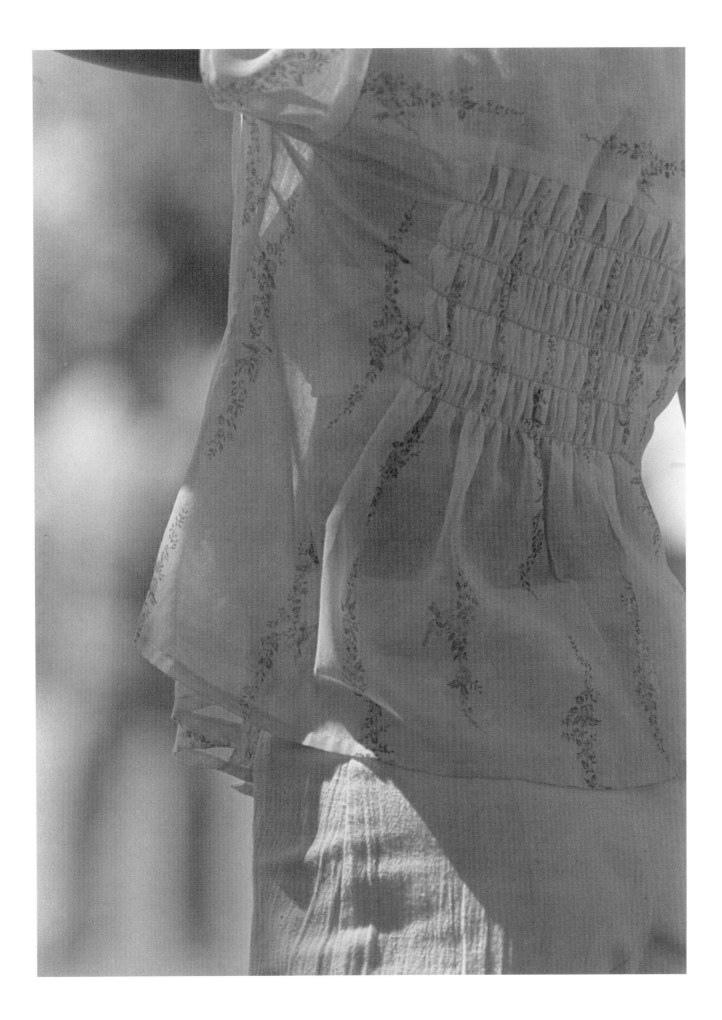

PLATE 67 Man walking away from broom, Washington, D. C., 1975

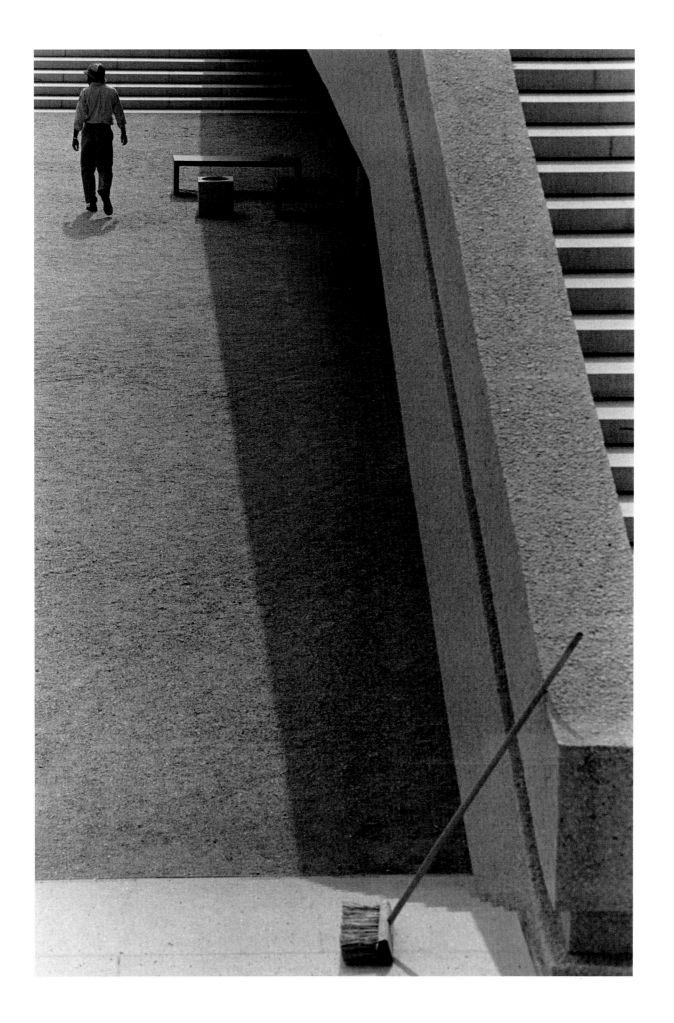

PLATE 69 Louise, Washington, D. C., 1975

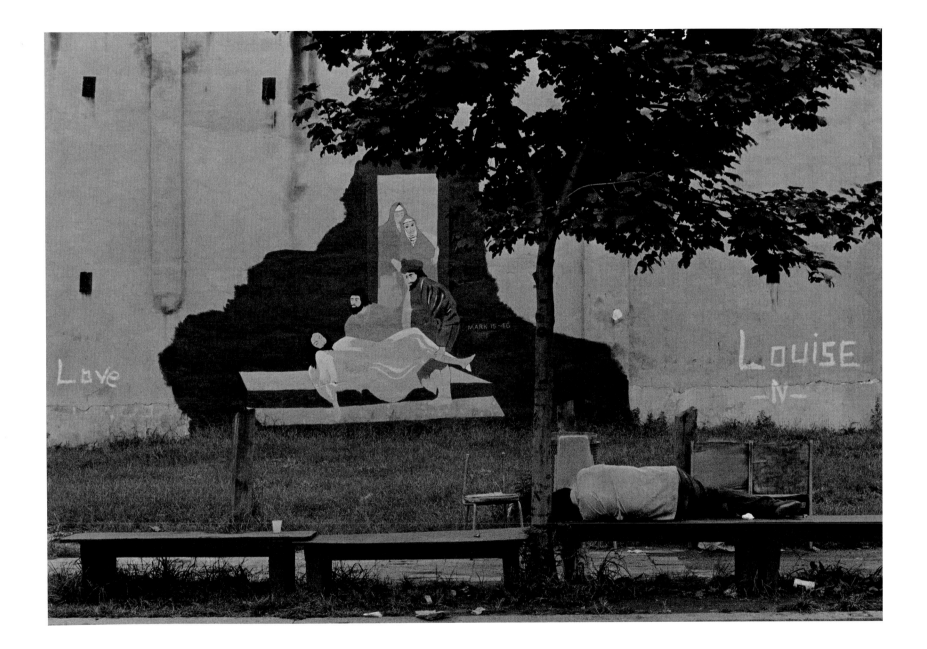

PLATE 70 Tombstones and trees, Washington, D. C., 1975

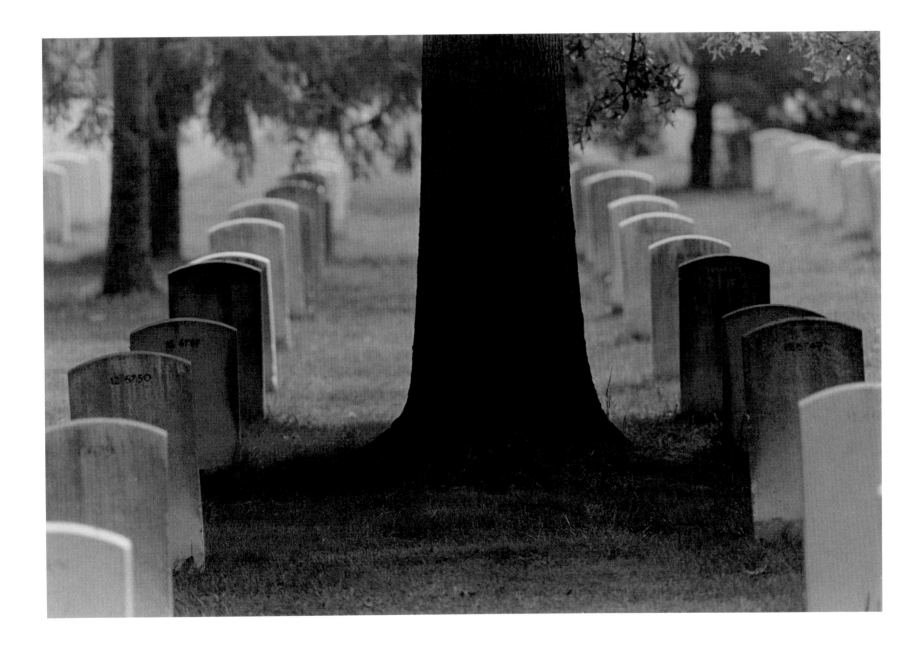

PLATE 71 Four arrows and towel, Washington, D. C., 1975

PLATE 72 Asphalt workers, Washington, D. C., 1975

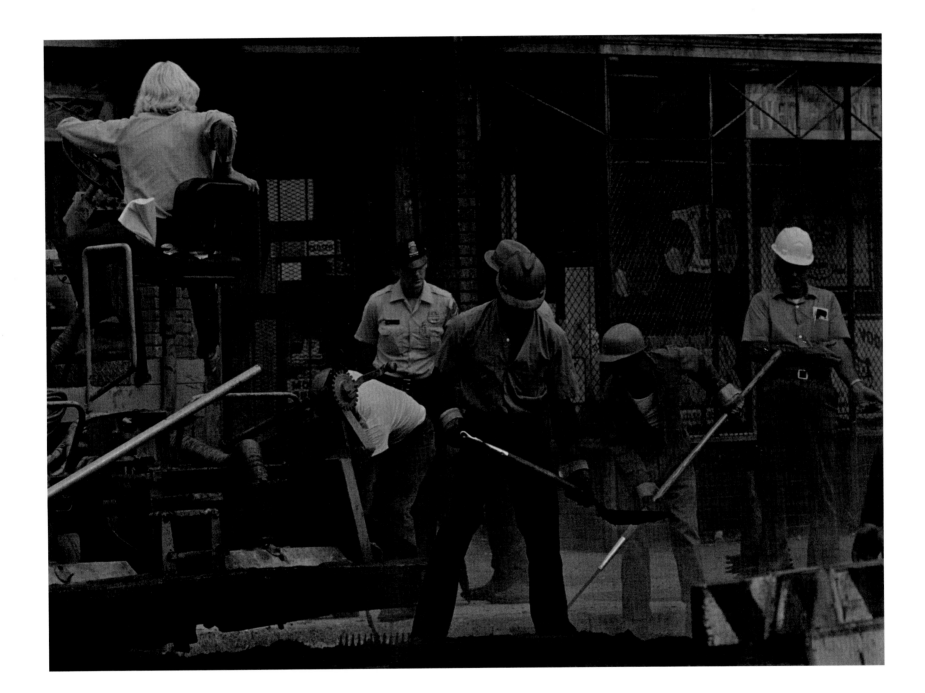

PLATE 73 Apartment for rent, New York, 1977

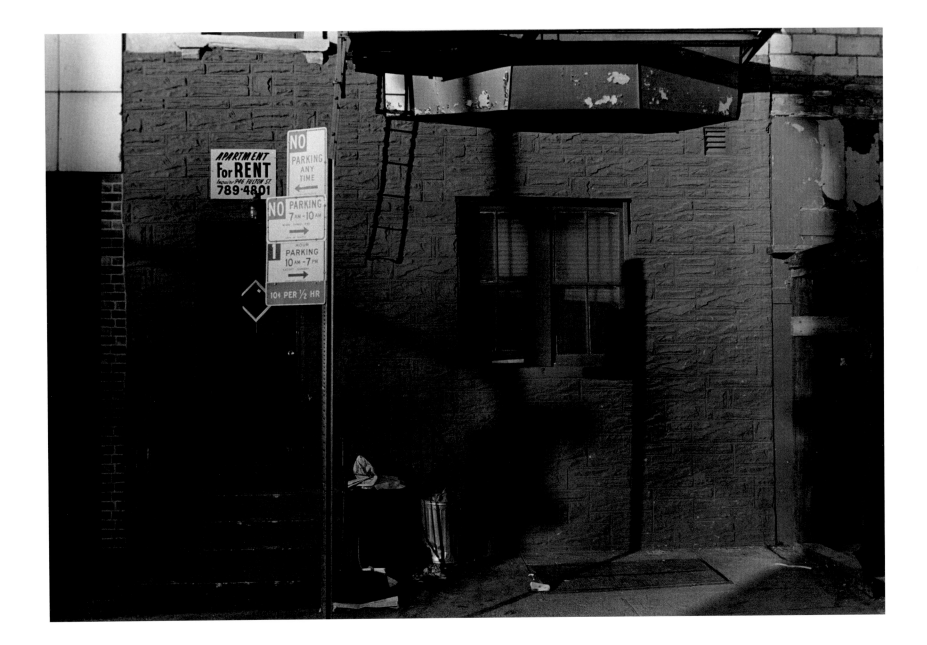

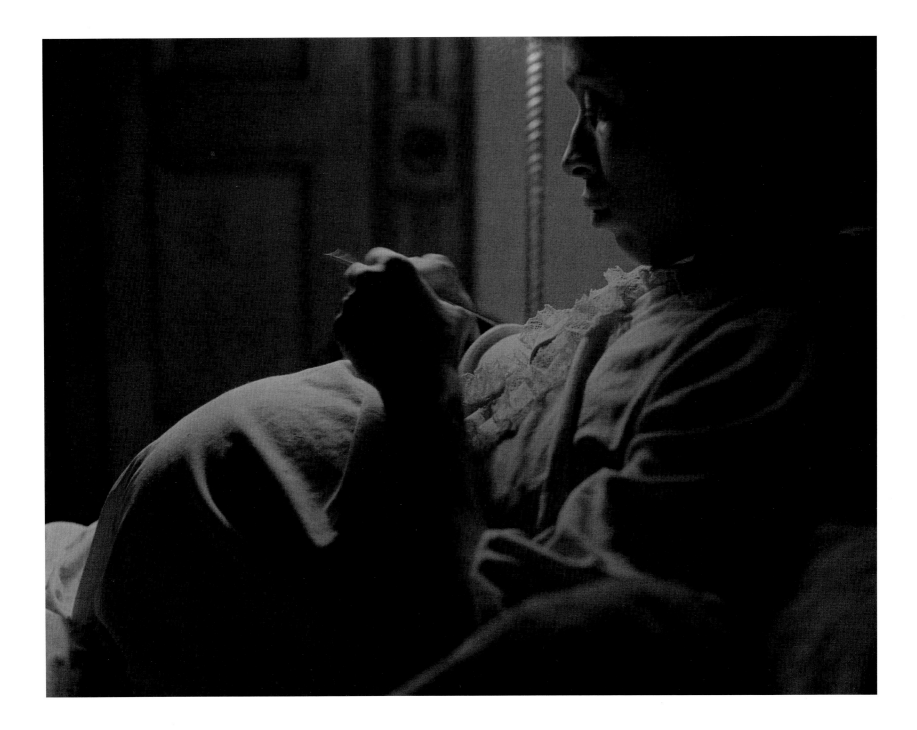

PLATE 75 Man in window, New York, 1978

PLATE 76 Man walking, Coney Island boardwalk, New York, 1978

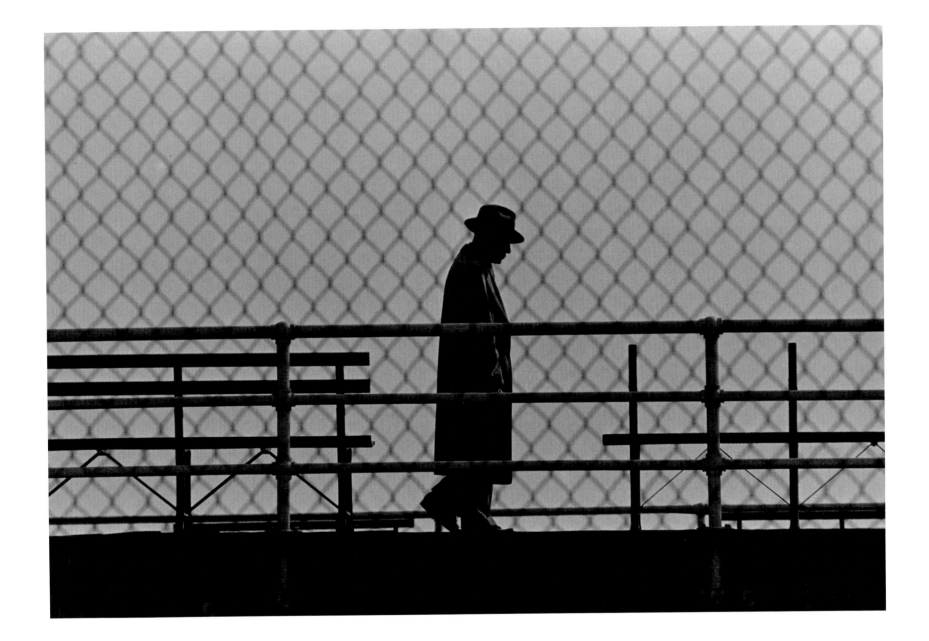

PLATE 77 Subway station, Canal Street, New York, 1978

PLATE 78 Boy in print shirt, New York, 1978

PLATE 79 Across the street, night, New York, 1978

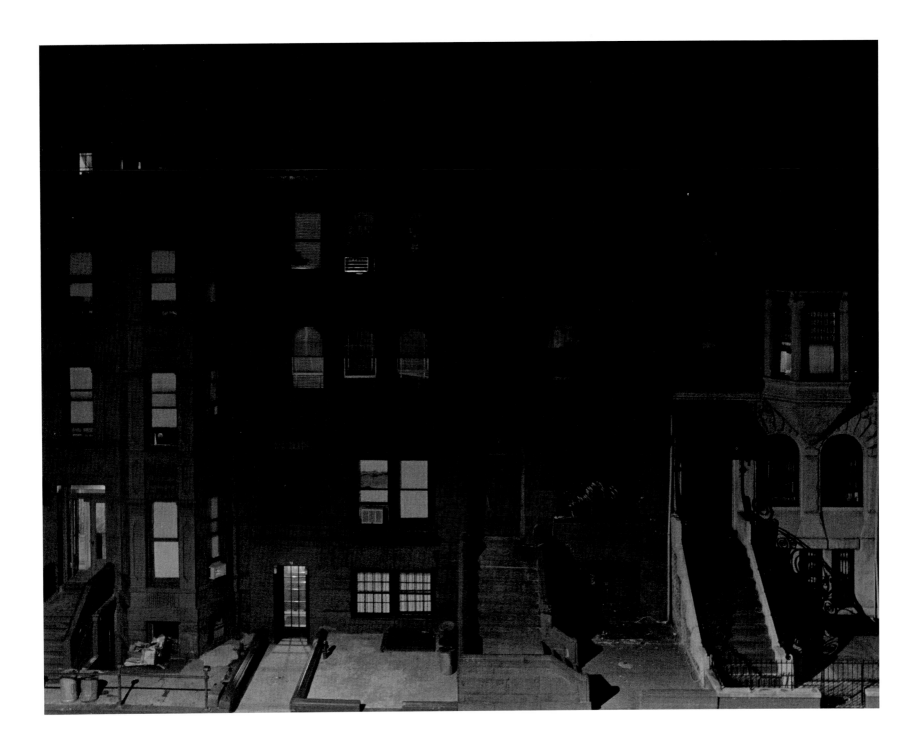

PLATE 80 Public School entrance, New York, 1978

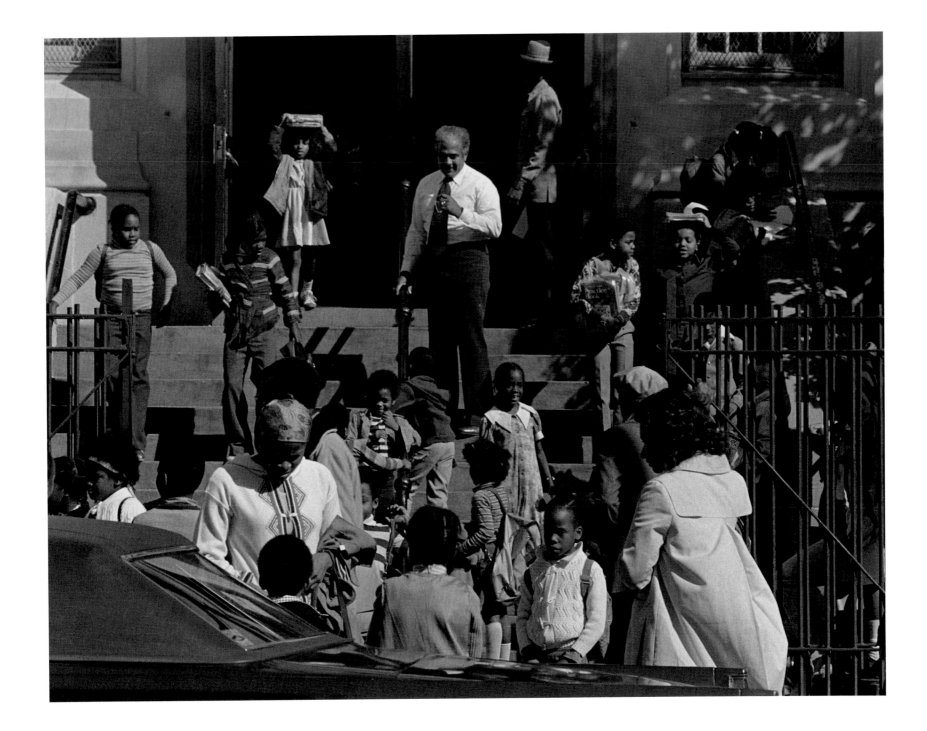

PLATE 81 Regal, New York, 1979

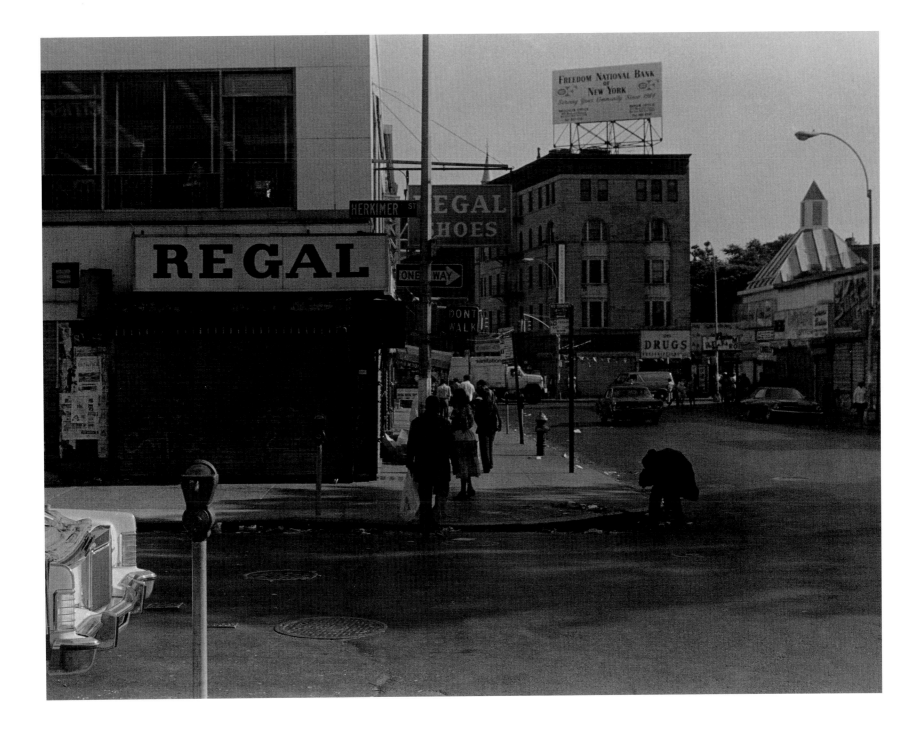

PLATE 82 4th of July, Prospect Park, New York, 1979

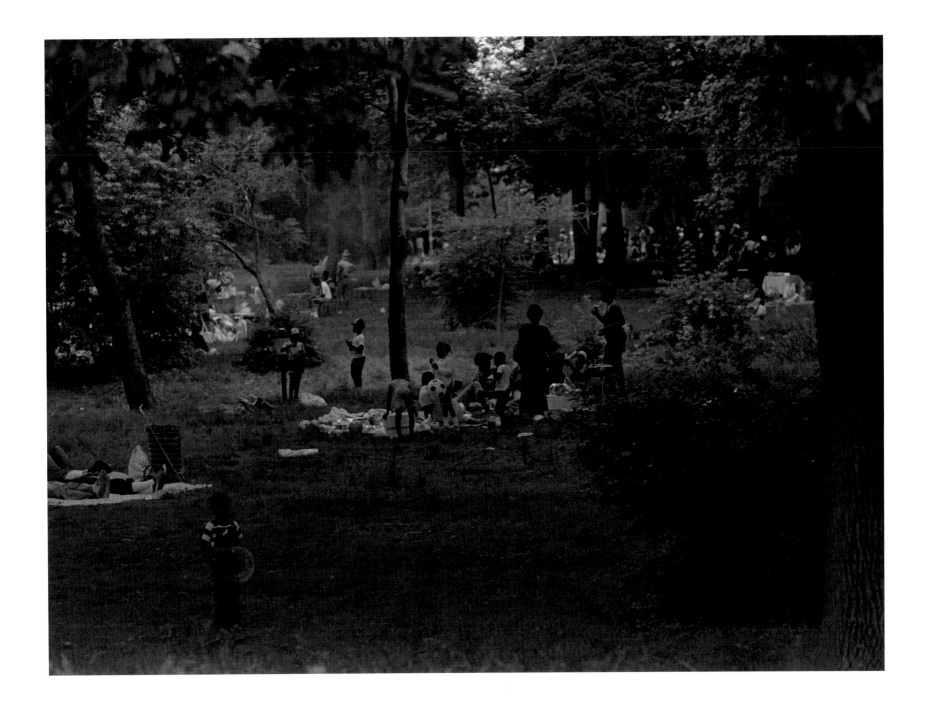

Chronology

1919
Born December 9, in Harlem Hospital, New York City.

1925-1934
Attends several New York public grammar schools, demonstrates a facility for art.

1929
Attends the Heckscher Foundation for Children, a neighborhood arts center.

1934-1938
Attends Textile High School in New York City with a major in art.

1938
Graduates from Textile High School and begins work in the poster division of the WPA project, New York City.

1938-1940
Wins city-wide competition for entrance to The Cooper Union Institute; attends Cooper Union at night while working as a commercial artist during the day for the WPA art project.

1939
Drawings appear on covers of *Crisis* and *Opportunity* magazines.

1940-1942
Attends the Harlem Art Center to study painting and printmaking.

1943
Begins work as a commercial artist producing technical illustrations.

1944-1945
Attends the George Washington Carver Art School; studies drawing and painting with Charles White.

1944-1946
Member, National Serigraph Society.

1946
Receives second prize for a serigraph print exhibited in the Atlanta University Annual, Atlanta, Georgia.

Begins to use photography as a means of sketching ideas for paintings.

1947
Makes decision to stop creating work in painting and serigraphy to become a photographer.

1948-1950
Joins the Committee for the Negro in the Arts, a community art organization sponsoring classes and activities for local Harlem residents. Becomes chairman of the art chapter.

1950
First one man show of photographs at the Forty-Fourth Street Gallery, New York City.(See exhibition list following for other one-man and group shows.)

Shows prints to Edward Steichen, Director of the Photography Department of the Museum of Modern Art. First print sales when Steichen buys two prints for the MOMA collection.

1952
Receives Guggenheim Foundation Fellowship in Photography, becomes the ninth photographer since 1937 and the first black artist to be so honored.

1954
Exhibition of photographs from the Guggenheim project at the Little Gallery, New York Public Library.

Founds and serves as Director for A Photographers Gallery, one of the first galleries in the United States devoted to the exhibition and sale of photography as a fine art.

1955
Simon and Schuster publishes *The Sweet Flypaper of Life*, with photographs by DeCarava and text by Langston Hughes.

1956
Begins to photograph jazz musicians intensively.

Closes A Photographers Gallery

1958
Quits work as a commercial artist to become a freelance photographer.

1960
New York 19, a Harry Belafonte Television Special, shown on CBS. Program was planned around specially commissioned DeCarava photographs taken in New York City's postal zone 19.

1963-1966
Serves as member, then Chairman, of the American Society of Magazine Photographers' Committee to End Discrimination against Black Photographers.

1963
Chairs public American Society of Magazine Photographers-sponsored meeting on the issue of discrimination against black photographers.

Founds the Kamoinge Workshop with several young black photographers.

1967
The Sweet Flypaper of Life reprinted by Hill and Wang.

1968
Pickets *Harlem On My Mind* exhibition at the Metropolitan Museum of Art, New York City.

1968-1975
Photographs under contract to *Sports Illustrated.*

1969
Receives Certificate of Recognition from the Mt. Morris United Presbyterian Church and Community Life Center for outstanding service rendered to the Harlem Community in the field of art.

Begins teaching course in photography at Cooper Union.

1970
Lectures at the University of Nebraska, Lincoln, in conjunction with exhibition at the Sheldon Memorial Art Gallery. Catalogue edited by Jim Alinder.

1972
Lectures in the International Fund for Concerned Photography Lecture Series at Columbia College, Chicago, and at New York University.

Lectures in the Cooper Union Lecture Series, New York.

Receives the Benin Award from the Benin Gallery, New York City, for contributions to the black communities as a creative photographer.

1974
Lectures at the University of Massachusetts, Boston.

Television interview with Casey Allen on *In and Out of Focus,* Channel 25, New York City.

1975
Lectures at the Museum of Fine Arts, Houston. Named Honorary Citizen and Goodwill Ambassador by the Mayor and city officials of Houston "in appreciation of his valuable contribution and unselfish public service for the benefit and welfare of mankind."

Receives appointment as Associate Professor of Art at Hunter College, New York.

1976
Interviewed at NBC News Center 4, New York City, by Cultural Affairs Editor Robert Potts.

Presents Gallery lecture at the Corcoran Gallery of Art, Washington, D.C.

Presents lecture and workshop at the Benin Gallery, New York City.

Participates in lecture and panel discussion *Third World Photography,* Photographer's Forum, New York City.

Does television interview for WABC-TV *Like It Is,* produced by Gil Noble, with discussion and viewing of Coltrane photographs published in the *Black Photographers Annual.*

Appointed to the Curatorial Council of the Studio Museum, Harlem.

1977
Does half-hour television interview with Anthony King on Channel D Cable TV, New York City.

Presents slide lecture at the Swarthmore College Umum Coloque, *The Roots of Black Art and Literature.*

Takes part in slide lecture and panel discussion, *Social Photography Today,* at the Brooklyn Museum.

Receives Focus Award from the Bedford Stuyvesant Camera Club, New York City.

1978
Lectures at the Port Washington Public Library, Port Washington, New York, and at the conference *Indigene-Anthology of Future Black Arts*, University of Pennsylvania, Philadelphia.

Receives commission to be one of twenty photographers invited by American Telephone and Telegraph to photograph the United States for a traveling exhibition and book.

1979
Receives award for Artistic and Cultural Achievement from New Muse, the Community Museum of Brooklyn.

Serves as faculty member for the Ansel Adams Workshop, Yosemite Valley, California.

Television presentation on *In and Out of Focus*, with Casey Allen, Channel 25, New York City.

Serves as juror for the New York State Photographic Awards.

Receives appointment as Professor of Art at Hunter College, New York City.

1980
Receives tenure at Hunter College.

Television interview shown on Black News, New York City.

Lectures at the Akron Art Institute, Ohio, and at the Summer Members Workshop, The Friends of Photography, Carmel, California.

Presents lecture and workshop at the Center for Creative Photography, University of Arizona. Does videotape with Jim Alinder for the Center's archive.

Presents lecture and slide exhibition at Gustavus Adolphus College, St. Peter, Minnesota.

ONE MAN EXHIBITIONS

1947
Serigraph Galleries, New York City (Serigraph prints)

1950
Forty-Fourth Street Gallery, New York City

1951
Countee Cullen, New York Public Library

1954
Little Gallery, New York Public Library (Guggenheim project photographs)

1955
A Photographers Gallery, New York City

1956
Camera Club of New York, New York City

1967
US, Countee Cullen, New York Public Library

1969
Thru Black Eyes, Studio Museum of Harlem, New York City

1970
Sheldon Memorial Art Gallery, University of Nebraska

1974
University of Massachusetts, Boston

1975
The Museum of Fine Arts, Houston

1976
Roy DeCarava, The Nation's Capitol in Photographs, Corcoran Gallery of Art, Washington, D. C.

1977
Witkin Gallery, New York City

1978
Port Washington Public Library, Port Washington, New York

1980
The Friends of Photography, Carmel, California

Akron Art Institute, Akron, Ohio

GROUP EXHIBITIONS

1953
Always the Young Stranger, Museum of Modern Art

Through the Lens, Caravan Gallery, New York City

1955
The Family of Man, Museum of Modern Art

Eight Photographers, A Photographers Gallery, New York City

1956
Group Show, A Photographers Gallery, New York City

1957
Seventy Photographers Look at New York, Museum of Modern Art

1958
Six Modern Masters, The Institute of Fine Arts Galleries, New York City

1960
New Acquisitions, Museum of Modern Art

1964
Photography in the Fine Arts, Metropolitan Museum of Art

1965
Fine Art Photographs, Edward Steichen Center, Metropolitan Museum of Art

1966
The Photographer's Eye, Museum of Modern Art

1974
Photography in America, Whitney Museum of American Art

1977
The Black Photographers Annual, The Corcoran Gallery of Art, Washington, D. C.

1978
Modern American Masters, Langston Hughes Community Library and Cultural Center, New York City

1979
Loan Exhibition, Office of the President of the New York City Council

Mirrors and Windows, Museum of Modern Art

1980
American Images, International Center for Photography, New York City

Photography of the Fifties, Center for Creative Photography, University of Arizona, Tucson

Silver Sensibilities, Newhouse Gallery, New York City

Bibliography

1953
Kouwenhoven, John A., *The Columbia Historical Portrait of New York*. New York: Doubleday & Company.

Popular Photography Annual. New York: Ziff-Davis Publishing Company.

U. S. Camera Annual. New York: U. S. Camera Publishing Company.

1955
DeCarava, Roy, and Langston Hughes. *The Sweet Flypaper of Life*. New York: Simon and Schuster. (German and Chinese editions published 1956 and 1958. Reprinted by Hill and Wang, 1967.)

Steichen, Edward. *The Family of Man*. New York: Simon and Schuster.

1964
Hansberry, Lorraine. *The Movement*. New York: Simon and Schuster.

1966
The John Simon Guggenheim Memorial Fellows in Photography.
Philadelphia: Philadelphia College of Art.

Szarkowski, John. *The Photographer's Eye*. New York: Museum
of Modern Art.

1967
Lyons, Nathan. *Photography in the Twentieth Century*. Horizon
Press.

1970
Alinder, Jim. *Roy DeCarava, Photographer*. Lincoln: University
of Nebraska Press.

Coleman, A. D. "Roy DeCarava: Through Black Eyes", *Popular
Photography*, vol. 66, no. 4, April, pp. 69-70ff.

1972
Alinder, Jim. "Roy DeCarava", *Creative Camera* No. 93,
March, pp. 528-535.

Gibson, Ray. "Roy DeCarava: Master Photographer", *Black
Creations*, New York University Afro-American Institute, vol. 4,
no. 1, Fall, pp 34-36.

1973
Black Photographers Annual. New York: Black Photographers
Annual, Inc.

Fax, Elton. *Seventeen Black Artists*. New York: Dodd, Mead & Co.

Szarkowski, John. *Looking at Photographs*. New York: Museum
of Modern Art.

1974
Black Photographers Annual, Volume 2. New York: Black Photographers Annual, Inc.

Doty, Robert. *Photography in America*. New York: Random
House.

1975
Black Photographers Annual, Volume 3. New York: Black Photographers Annual, Inc.

Short, Alvia Wardlaw. *Roy DeCarava: Photographs*. Houston:
The Museum of Fine Arts.

1976
Roy DeCarava, The Nation's Capitol in Photographs, 1976.
Washington, D. C.: The Corcoran Gallery of Art.

1978
Szarkowski, John. *Mirrors and Windows*. New York: The
Museum of Modern Art.

1979
Coleman, A. D. *Light Readings*. London: Oxford University
Press.

1980
Danese, Renato. *American Images*. New York: McGraw-Hill.

Gee, Helen. *Photography of the Fifties*. Tucson, Arizona: Center
for Creative Photography.

ACKNOWLEDGEMENTS

Having personally felt the need for this book for more than a decade, it is particularly rewarding to be able to publish it in an uncompromising manner. I would like to thank all those whose efforts have made this project a reality. Roy DeCarava has been most generous. He has participated in all aspects of the making of this book. Sherry Turner DeCarava wrote diligently under the pressure of our deadlines and has produced a remarkable essay. The staff of The Friends has been central to the book's production. Particularly important contributions were made by David Featherstone in the copy editing and Peter A. Andersen in the design. Thanks also to staff members Debbie Bradburn, Libby McCoy, Nancy Ponedel and Mary Virginia Swanson. Other important contributions were made by Ansel Adams, Mary Alinder, Robert Baker, Chris Rainier and Peggy Sexton. In addition, I would particularly like to thank Zeke Kennedy of Kennedy Typography, who set the type, and Dave Gardner of Gardner/Fulmer Lithograph, whose caring about the perfection in photographic reproduction has made this a most beautifully printed book.

This publication was funded, in part, by generous grants from the National Endowment for the Arts, a Federal Agency, and from The Center for Creative Photography of the University of Arizona. Their assistance is greatfully acknowledged.

James Alinder
Editor

THE FRIENDS OF PHOTOGRAPHY

The Friends of Photography, founded in 1967, is a not-for-profit membership organization with headquarters in Carmel, California. The Friends actively supports and encourages creative photography through wide-ranging programs in publications, grants and awards to photographers, exhibitions, workshops, lectures and critical inquiry. The publications of The Friends, the primary benefit received by members of the organization, emphasize contemporary photography yet are also concerned with the criticism and history of the medium. They include a monthly newsletter, a quarterly journal and major photographic monographs. Membership is open to everyone. To receive an informational membership brochure write to the Membership Director, The Friends of Photography, Post Office Box 500, Carmel, California 93921.